Without
Boundary

Without Boundary: Seventeen Ways of Looking

THE MUSEUM OF MODERN ART, NEW YORK

FERESHTEH DAFTARI

with an essay by

HOMI BHABHA

and prose by

ORHAN PAMUK

Published in conjunction with the exhibition *Without Boundary: Seventeen Ways of Looking*, organized by Fereshteh Daftari at The Museum of Modern Art, New York, February 26–May 22, 2006

The exhibition is supported in part by The International Council of The Museum of Modern Art and by Sheila and Hassan Nemazee.

Additional funding is provided by Nathalie and Amir Farman-Farma, Gulin Ongor, the Persian Cultural Foundation, Judy and Steven Gluckstern, the Nazem Family Foundation, Ali Reza Rastegar, Rohit and Katharine Desai, and Dinyar S. Devitre.

Produced by the Department of Publications, The Museum of Modern Art, New York

Edited by David Frankel
Designed by Bethany Johns
Production by Marc Sapir
Printed and bound by
Dr. Cantz'sche Druckerei, Ostfildern

This book is typeset in the font family Swiss 721, designed by Max Meidinger (1910–80) of Zurich and released by Bitstream. The paper is 170 gsm Lumisilk

Printed in Germany

Published by The Museum of Modern Art,
11 W. 53 Street, New York, New York 10019

© 2006 The Museum of Modern Art, New York

Orhan Pamuk's text was translated from the Turkish by Maureen Freely

Credits for certain illustrations are cited on p. 109. All rights reserved

Distributed in the United States and Canada by D.A.P./Distributed Art Publishers, Inc., New York Distributed outside the United States and Canada by Thames & Hudson Ltd, London

Library of Congress Control Number:
2005938469
ISBN: 0-87070-085-5

Cover: Shahzia Sikander. *Perilous Order* (detail). 1997. Vegetable pigment, dry pigment, watercolor, and tea water on paper, $10\,3/8$ x $8\,3/16$" (26.4 x 20.8 cm). Whitney Museum of American Art, New York. Purchase, with funds from the Drawing Committee, 1997. See plate 9

Frontispiece: Shirazeh Houshiary. *Fine Frenzy* (detail). 2004. Black and white Aquacryl, white pencil, and ink on canvas, 6' $2\,3/16$" x 6' $2\,3/16$" (190 x 190 cm). Private collection. See plate 1

Contents

Foreword

Without Boundary sets out to look at the work of a number of contemporary artists who come from the Islamic world but live and work elsewhere, in such globally dispersed cities as London, Paris, Zurich, Buenos Aires, and New York. Taking note of a range of these artists' reactions to the legacy of Islamic art, as well as to issues of identity and faith, the exhibition emphasizes the enormous diversity of the work that is emerging from what is simplistically viewed as a homogeneous culture.

At its onset, the project gained a great deal from the viewpoints expressed by an advisory group consisting of Homi Bhabha, Oleg Grabar, Mohsen Mostafavi, and Reinhard Schulze. I would like to extend my sincere appreciation for their input. The exhibition was organized by Fereshteh Daftari, Assistant Curator in the Museum's Department of Painting and Sculpture, whose viewpoints were shaped by her own experience growing up in the Middle East, as well as by her life in Europe and the United States. While Daftari's essay in this book documents the artists and their works, Homi Bhabha's contribution to the publication provides a beautifully elegant conceptual approach to the issues at hand. Finally, between these two essays falls a short prose piece by the prominent Turkish novelist Orhan Pamuk, who takes on the voice of a traditional work of Islamic art.

This exhibition has very much benefited from the financial support of The International Council of The Museum of Modern Art and of Sheila and Hassan Nemazee, as well as from the additional funding provided by Nathalie and Amir Farman-Farma, Gulin Ongor, the Persian Cultural Foundation, Judy and Steven Gluckstern, the Nazem Family Foundation, Ali Reza Rastegar, Rohit and Katharine Desai, and Dinyar S. Devitre. We are also indebted to the many lenders to the exhibition, both private and public. Finally and especially I would like to thank the artists for their participation in *Without Boundary*, as well as for their prized contribution to contemporary art.

GLENN D. LOWRY
Director, The Museum of Modern Art

Acknowledgments

I would like to begin by thanking those on The Museum of Modern Art's Exhibition Committee who supported my proposal for *Without Boundary*, and especially Glenn D. Lowry, the Museum's Director, whose interest in both the Islamic world and contemporary art helped to turn this project into a reality. Despite his hectic schedule he remained accessible and generous with both insightful advice and constructive criticism throughout the exhibition's production. My special thanks also go to John Elderfield, The Marie-Josée and Henry Kravis Chief Curator, Department of Painting and Sculpture, not only for his initial support of *Without Boundary* but also for his help in a number of specific areas. Thanks also to Kynaston McShine.

Among the organizers of an exhibition it is usually the curator who gets the most attention, but the production of an exhibition and its catalogue is a team project demanding the assistance and collaboration of a great many individuals and institutions. Inside the Museum I would like to highlight the contribution of Michelle Yun, Curatorial Assistant, who has worked on the show from day one and compiled the artists' biographies. I have benefited not only from her professionalism and research skills but from her tact, warmth, and thoughtfulness, which have sustained me in all circumstances.

In the Department of Publications I am most indebted to David Frankel, Managing Editor and editor of this book, and to his inspiring standard of excellence. In the same department I would like to thank Marc Sapir, Production Director, for his perfectionism, as well as Christopher Hudson, Publisher; former Publications Manager Lawrence Allen; Brian Stauss, Business Manager; and Rebecca Zimmerman, Promotions/Marketing Coordinator. Coming in from outside the Museum, Bethany Johns gave the book its beautiful design. In the Department of Graphics my gratitude goes out to Claire Corey, Production Manager, and to Jill Weidman, Senior Graphic Designer.

I cannot sufficiently thank Marci Regan Dallas, Assistant Coordinator of Exhibitions, for her responses to my many queries. I equally wish to thank Jennifer Manno and Randolph Black, Assistant Coordinators, and Maria DeMarco Beardsley, Coordinator, in the Department of Exhibitions. In the Department of Exhibition Design and Production I thank Lana Hum, Production Manager, for her sensitive design of the exhibition; Peter Perez, Framing Conservator, for his outstanding work; and Jerry Neuner, Director, whose infallible eye helped me find my way in the initial stages of the process. Charlie Kalinowski, Media Services Manager in Information Technology, deserves special thanks. Ramona Bannayan, Director of Collection Management and Exhibition Registration, and her superb team— Kerry McGinnity, Senior Registrar Assistant, and Heidi O'Neill, Associate Registrar—deserve my gratitude. Heidi's coordination of the transportation of the artworks deserves a special salute. In the same department, my warmest appreciation goes to Pete Omlor, Manager; Rob Jung, Assistant Manager; and Stan Gregory and the rest of the team of art handlers. In the general area of Exhibitions no acknowledgment would be complete without mentioning the formidable Jennifer Russell, Senior Deputy Director.

My very special thanks go to Jennifer Tobias, Librarian, for her magical abilities in making all kinds of publications available and in facilitating research. I would also like to thank David Senior, Librarian, for his help in the same domain. Deborah Schwartz, Deputy Director for Education, deserves grateful acknowledgment, along with her wonderful team: David Little, Director of Adult and Academic Programs; Laura Beiles, Assistant Educator; Sara Bodinson, Associate Educator; and Sarah Ganz, Director of Educational Resources.

In the office of the General Counsel, Nancy Adelson, Associate General Counsel, and Stephen Clark, Deputy General Counsel, provided invaluable help. In Communications I would like to thank Ruth Kaplan, Deputy Director; Kim Mitchell, Director of Communications; Daniela Stigh, Manager; and Meg Blackburn, Senior Publicist. In Marketing, Peter Foley, Director, and Mark Swartz, Writer/Editor, made much appreciated contributions. In Exhibition Funding, Todd Bishop, Director, and Mary Hannah, Assistant Director, have been a delight to work with. I must also

thank Rebecca Stokes, Director, Campaign Services, in the Department of Development and Membership.

No exhibition is fun without an opening but an opening is hard work. Here several people must be acknowledged: Robert Basinger, Event Coordinator; Elizabeth Pizzo, Senior Event Coordinator; and Paola Zanzo-Sahl, Assistant Director, all three in the Department of Special Programming and Events.

Professionals in various departments have helped to move the project along in many ways, and I do not want their names to be omitted: Diana Pulling, Executive Assistant to the Director; Gael LeLamer, Senior CEMS Assistant, Department of Collection and Exhibition Technologies; and close to home in the Department of Painting and Sculpture, Mattias Herold, Department Manager, and Sharon Dec, Assistant to the Chief Curator. Karl Buchberg, Senior Conservator, will be the exhibition's point person in the Department of Conservation and has my warmest appreciation. I also want to note my appreciation of Joachim Pissarro's strong enthusiasm for this project as well as the support of Anne Umland and Ann Temkin, all three of them curators in the Department of Painting and Sculpture.

Finally, within the Museum, I extend my warmest gratitude to Jay Levenson, Director of the International Program, who has been most supportive. I very much look forward to the symposium he is organizing in conjunction with this exhibition. And I cannot sufficiently thank Carol Coffin, Executive Director, International Council, for travel grants that have allowed me to comb through exhibitions and meet artists abroad, as well as for generously funding this exhibition.

Outside the Museum, the first people I would like to thank are the artists themselves. Shunning reductive categorizations, they have trusted me fully not to ghettoize their work and have been patient with my numerous queries. Some are also lenders to the show. I am most grateful to them.

A loan show like this one, in which every work is borrowed, would simply not have happened without the generosity of the lenders. I would like to thank them, the galleries representing the artists, and the curators at other institutions who have made the sailing smooth. I must particularly mention a few individuals who have done more than their share in helping me with a range of issues: Ted Bonin, of Alexander and Bonin, New York, and David Maupin and Rachel Lehmann, of Lehmann Maupin Gallery, New York. At Lehmann Maupin a huge thank you must also go to Jan Endlich, Associate Director. Glenn Scott Wright and Victoria Miro of the Victoria Miro Gallery, London, have my deepest appreciation. Special thanks also go to Elly Ketsea at the Lisson Gallery, London; Meg Malloy, Partner, Sikkema Jenkins & Co., New York; and Brian D. Butler of 1301PE, Los Angeles. I also owe thanks to several curators, including Kris Kuramitsu, Norton Family Office;

Arabella Makari, Curator for Agnes Gund and Daniel Shapiro; Andrea Rose, Visual Arts Director, British Council; and Lynn Zelevansky, Curator of Contemporary Art, Los Angeles Contemporary Museum of Art.

I have benefited enormously from the advice of several individuals who constituted an advisory board that met at the Museum in March of 2005. To begin with I cannot sufficiently thank Oleg Grabar, Professor Emeritus at the Institute for Advanced Study in the School of Historical Studies at Princeton. His kindness and generosity are without boundary, if I may use that phrase. Homi Bhabha, Anne F. Rothenberg Professor of English and American Literature, Harvard University, has been a fountain of insight as well as a precious contributor to the project as the author of an essay in the catalogue. It has been my privilege to get to know him and he has my warmest regard. (His assistant, Mark Jerng, must be mentioned here as well.) The presence on the advisory board of Mohsen Mostafavi, Dean of the College of Architecture, Art and Planning, Cornell University, was very much appreciated. Unfortunately Reinhard Schultze, Professor of Islamic Studies at the University of Bern, Switzerland, was unable to make it to the meeting but the notes he sent us were tremendously enlightening.

In the area of Islamic art I was fortunate to be able to consult not only Oleg Grabar but Massumeh Farhad, Chief Curator and Curator of Islamic Art, Freer and Sackler Galleries, the Smithsonian Institution. Still another person I am indebted to in scholarly matters concerning the Islamic world is my own brother, Farhad Daftary, Associate Director, Institute of Ismaili Studies, London. Doing away with professional courtesy, I have called on his expertise at all hours of the day and night. Lastly I would like to express an especial gratitude to Orhan Pamuk for his contribution to this catalogue, in which he speaks from the vantage point of an older work of Islamic art.

These acknowledgments would be incomplete without a particular word of thanks to The International Council and to Sheila Nemazee for their backing of *Without Boundary*, as well as for Sheila's efforts in gathering support and spreading the word about it. Thank you to both Sheila and Hassan Nemazee. I also owe profound thanks to the exhibition's other financial supporters: Nathalie and Amir Farman Farman-Farma, Gulin Ongor, the Persian Cultural Foundation, Judy and Steven Gluckstern, the Nazem Family Foundation, Ali Reza Rastegar, Rohit and Katharine Desai, and Dinyar S. Devitre.

And finally we come to the end, where I would like to thank anyone I should have thanked but have failed to.

FERESHTEH DAFTARI

Assistant Curator, Department of Painting and Sculpture,
The Museum of Modern Art

ISLAMIC OR NOT

Fereshteh Daftari

We often think of artists in terms of their origins, even when much of their life and work takes place elsewhere. This is problematic with artists from the Islamic world, particularly in light of the intense attention currently directed toward Islam from the West.[1] In academic curricula and lectures, and in articles in the art press, artists such as Mona Hatoum, Shirin Neshat, and Shahzia Sikander—of Palestinian, Iranian, and Pakistani origin respectively—are regularly described as "Islamic."[2] Yet these artists share neither nationality nor religion, have studied in Europe and the United States, and live and work in London and New York.

When the adjective "Islamic" is so regularly attached to quite different bodies of art, the question bears asking whether it is applicable to them. The region we call "the Islamic world" stretches from Indonesia to the Atlantic coast of Africa; to call the art of this entire area "contemporary Islamic art" is surely reductive, like calling the art of the entire Western hemisphere "contemporary Christian art." *Without Boundary* sets out to look at the work of a number of artists who come from the Islamic world but do not live there. Only active consideration of this kind will slow down the race toward simplistic conclusions and binary thinking.

The study of "Islamic art" is an occidental invention, originating in Europe in the 1860s.[3] Definitions of the term vary from one context to another; the scholar Oleg Grabar cuts through them by defining Islamic art as "art made in and/or for areas and times dominated by Muslim rulers and populations."[4] In our present polarized moment, the term is loaded with political and religious subtexts, and yet it has been applied to artists who would not necessarily use it to describe their own work, who do not live permanently in Islamic areas, and who produce art for European and American art spaces in which Muslim visitors are only a fraction of their audience. Is there any identifiable commonality in their art?

Without Boundary approaches its subject from a variety of perspectives, the first of them formal. Classic traditions of Islamic art that have become well-known in the West include, for example, calligraphy, the painting of miniatures, and the design of carpets. These forms might lead a Western viewer to label an artwork "Islamic." To explore to what measure the artists in *Without Boundary* actually depart from any conventional notion we might have of Islamic art, then, this exhibition and book will examine their work in part by approaching it through just these taxonomic types. A second focus of *Without Boundary* is the question of identity, whether secular or religious—a frequent issue in an exhibition of artists the majority of whom have experienced long-term dislocations across national borders. Finally, since the Western sense of Islamic art is tied deeply to religion, a third section of the exhibition explores questions of faith.

In all of these areas, the artists in *Without Boundary* defy the expectations imposed by the term "Islamic art"—a term that was in any case originally devised in reference to traditional art forms. To impose categories on artists who resist categorization, of course, is a contradiction in terms, and I do not intend *Without Boundary* to share in the homogenizing impulse that has become so widespread. To highlight the difficulty of making origin a defining factor in the consideration of art, then, the exhibition also includes two Western artists, and one or two more will be discussed in this essay. Although not influenced by artists from the Islamic world, these artists share interests, references, and strategies with them.

Text versus Calligraphy

Calligraphy, through its ancient association with the Koran, holds a privileged position in the aesthetic traditions of the Islamic world (fig. 1).[5] The medium of both religious and secular texts, it has evolved into distinct styles running from the minimal to the highly ornate, from the angular to the fluidly cursive. Written in many languages but always in the Arabic alphabet, these styles follow rules but also allow variation, even sometimes quite radical experimentation, so that in some countries recent modes of calligraphy are seen as local expressions of modernism.[6]

The paintings of **SHIRAZEH HOUSHIARY** are abstractions in which neither traditional nor modernist calligraphy is immediately recognizable, yet all of these works rely on a basic building block: a word, inscribed from right to left in Arabic script. Repeated, sanded down, and rewritten to the point where areas of the painting come to resemble a web of cracks, Houshiary's words are illegible, indeed virtually invisible, and she has not revealed their content. The mark dissolves; a trace of the art-making activity, it moves between being and nonbeing, "between existence and nonexistence," as Houshiary says.[7] Working on canvases laid on the floor, Houshiary seems intent on drawing out of their fabric an echo of presence so faint that it equally signifies absence. Summoning paradoxes and dualities in order to transcend them, she turns to a palette of oppositions: black and white, darkness and light, life and death.

2. Shirazeh Houshiary. *Gaze*. 2003. White Aquacryl and graphite on canvas, 6' 2 13/16" x 6' 2 13/16" (190 x 190 cm). The artist and Lehmann Maupin Gallery, New York

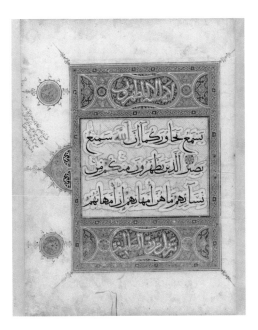

1. Page in a Koran (Sura 53, verses 1–2). 14th century. Ink, opaque watercolor, and gold on paper, 14 1/2 x 10 5/8" (36.9 x 27 cm). Freer Gallery of Art and Arthur M. Sackler Gallery, Smithsonian Institution, Washington D.C. Purchase

A central metaphor in Houshiary's work is light. *Gaze* (2003; fig. 2), for instance, seems to flicker and vibrate, mirroring the act of seeing. Erasing what Houshiary calls the "distinction between the viewer and the painting,"[8] the work moves beyond purely optical sensation by calling on the viewer to experience awareness. Seeking the possibility of illumination, Houshiary asks literal text to release ultimate sense.

In *Fine Frenzy* (2004; plate 1) the word becomes the epicenter of an explosion. On the one hand writing seems pulverized and atomized, on the other, still clinging like particles of dust—or conversely of light—to the surface of the canvas, it seems to expand beyond the work's borders, and beyond any physical geography. The source of light in the work—a word, present at the painting's inception, expanded into a vortex of energy—is born in darkness. Houshiary is an admirer of Minimalism (born in Iran, she moved to London in 1974 and studied at the Chelsea School of Art, so that her artistic formation is Western) but she finds in that idiom of reduction and repetition not the theoretical and spatial issues that usually determine discussion of it but a language of meditation. In the tradition of abstract painting, meanwhile, her predecessors might be Mark Rothko, Ad Reinhardt, and Agnes Martin, whose work similarly had mystical

aspects. Unlike those artists, though, she arrives at abstraction by concealing a text.

Unlike Houshiary, the Algerian artist **RACHID KORAÏCHI** makes his text highly visible, embroidering it in gold letters on large silk tapestries. Yet the sign system he mostly uses is his own invention, and indecipherable. The message is coded. Even when Koraïchi does use Arabic script—when he inscribes his signature and the date at the bottom of a tapestry, for example— he usually writes it backward. The mirror image has an important place in Islamic thought; as the artist points out, for example, the Sufis believe that knowledge of the self is never direct, and must always rely on the mirror.[9]

Salome (plate 6), a series of twenty-one textiles from 1993, tells a veiled and cryptic tale, according to Koraïchi, about a doomed personal relationship, while also referring in its title to the biblical story of the infamous dance that led to the death of John the Baptist.[10] In choosing this text, Koraïchi underlines the importance of Christianity in Algeria, a hybrid nation in religious terms. His ideograms, too, have links to the many visual cultures of North Africa, old and young, including numerology, Talismanic inscriptions, calligraphy, tattoos, Sufi banners, and the rock paintings of the Ahaggar region of Algeria, to name a few. Adding to this gene pool in *Salome* is a symbol found in Ancient Egyptian tombs, to which Koraïchi draws attention with arrows: the boat that carries life beyond the grave. Among all these references, a family resemblance to the banners (fig. 3) of Islamic North Africa remains apparent.

KUTLUG ATAMAN is best known for video installations incorporating interviews with people who are in some way exceptional or remarkable. Since the interview by nature involves language and narrative, it is consistent with Ataman's practice that he should also have turned to writing, a basic medium of these modes. In a series of six animated videos from 2003, he addresses the separate semiotic premises of word and image, which he shows merging, separating, and merging again. An image pregnant with meaning hides words; words become moving images, as if aspiring to visual status. In this sense Ataman's animations are metaphors for film- and videomaking.

World (no. 1) (2003; plate 4) and *Beautiful (no. 2)* (2003; plate 5), each containing the Turkish word of its title, combine this interest in cinema with an origin in a marginal tradition of calligraphy in which artists design religious invocations in the form of horses, lions, birds, and sometimes human faces (fig. 4). Returning to this verbal/visual genre but rendering it secular, Ataman also returns to the use of Arabic script, which the modern founding figure of his native Turkey, Kemal Atatürk, banned in 1929 in the so-called "alphabet revolution," part of the country's project of modernization. The ornamental letters of Ataman's calligraphy, then, belong to an outcast alphabet, a status some-times elaborated through the profane spirit of these animated works—as in *World*, where the letters, as they rotate, form into a phallic erection.

If video animation and Islamic calligraphy are newly allied in Ataman's work, handwritten calligraphy also makes a strange

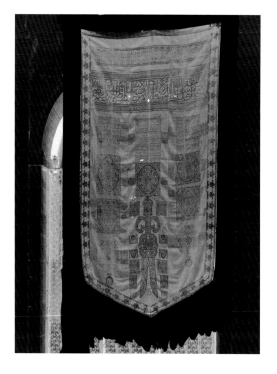

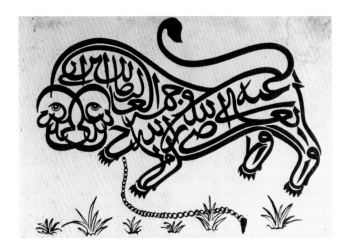

3. North African pilgrim's banner. 1683. Silk, 12' 1 1/2" x 6' 3" (369.57 x 190.5 cm). Arthur M. Sackler Museum, Harvard University Art Museums, Cambridge, Mass. Gift of John Goelet

4. Lion formed of ornamental Tawqi script. Persian, probably 19th century. The script reads in English, "Ali ibn Abi Talib, may God Almighty be pleased with him and honor him"

5 and 6. Ghada Amer. *Love Park.* 1991. Paired signs and benches. Installation view, park adjacent to SITE Santa Fe exhibition

Men admire women who are healthy, of the right stature, with voluptuous flesh, and a light and glowing complexion. They smell good. Their shoulders are broad, their arms long, their forearms fleshy. Their mouths are small with crimson-red lips that are soft, relaxed, generous, and plump. They have narrow and pleasing noses. They have noble faces which, in the opinion of some, should be round in shape.

Women admire men who show initiative, who are meticulously well groomed, who stand out in their social group and who have the best character, with a refined physical stature and pleasant features. They never lie when they speak to women and their words are truthful. These men are liberal, courageous, generous, and are easy to live with. When they say something they mean it, and when they give their word, they honor it. These men can be trusted.

bedfellow for the mechanically reproduced medium of photography. The early work of **SHIRIN NESHAT**, however, involves just this partnership, comprising words in Persian handwritten on her photographs to render each print unique. "I was always fascinated by the art of calligraphy," Neshat recalls, "and most importantly in how text and image fuse in both Persian and Islamic art, from miniature paintings to other forms. Also, I collected in Tehran's bazaars small plates, good luck charms, where mythological figures of men, women, and animals are completely covered with inscriptions, both inside and outside."[11] In works of this kind Neshat replays the upheavals she found when she visited Iran in 1990, after a sixteen-year absence. (She had left as a teenager in 1974, five years before the revolution that toppled Shah Mohammed Reza Pahlavi.) The contradictions implicit in these works show her grappling with a revolution that had turned the familiar into the uncanny.

In *Speechless* (1996; plate 3), from the Women of Allah series, begun in 1993, a woman wears a gun barrel in place of an earring, while her face is veiled with script—a eulogy to martyrdom in the name of Islam, quoted from the writings of the contemporary Iranian poet Tahereh Saffarzadeh. Evoking the alliance between religion and politics in postrevolutionary Iranian culture, *Speechless* also considers the revolution's empowerment of the social classes that toppled the Westernized regime of the shah. In *Untitled* (1996; plate 2), meanwhile, a photograph from the same series, Neshat points to an internal discord, this time writing text on the hand of a woman shown raising her fingers to her lips. The gesture might signal a kiss as well as a self-imposed silence, and this time Neshat quotes Forough Farrokhzad (1935–67), a poet known for the sensuality of her writing—in fact a poet whose writings fell into official disfavor

in postrevolutionary Iran. Neshat lets the poem grow vertically on the hand's upward-pointing fingers; below, on the back of the hand, is a religious invocation, set in a circle and written in letters evoking traditional Islamic calligraphy. Disputing the divisions in culture that she saw in postrevolutionary Iran, Neshat sets on the same body an assertion of faith and the words of a poet of life.

This fusion of religion and sensuality is often missed in the West, where the women in Neshat's images are frequently interpreted as one-dimensional Islamic types. The writing on Neshat's photographs has been similarly misunderstood: an audience that does not read Persian, and may not distinguish clearly between Iranians and Arabs, assumes that her texts are in Arabic and perhaps even excerpted from the Koran, which Neshat has actually never quoted.[12] **GHADA AMER** leaves less room for misunderstanding. Even when she was still a student, at the Ecole des Beaux-Arts in Nice, Amer defied a teacher's expectation that this Egyptian-born artist might use Islamic calligraphy. Instead she chose to work with Roman script, legible to her audience in France.[13] The sources of her text works range a wide territory, from banal popular culture (fashion magazines) through reference material (the French dictionary *Le Petit Robert*) to translations from historical Arabic literature. In *Love Park* (figs. 5 and 6), for instance, made for a town park adjoining the SITE Santa Fe exhibition of 1991, Amer planted signposts inscribed with quotations from Sheikh Nefzawi's *Perfumed Garden*, an erotic handbook written in North Africa in the sixteenth century—and perfectly respected, no anomaly, in the Arab world of its time.[14] The critic Olu Oguibe accordingly notes of Amer, "Her work may be seen as the continuation of a long tradition of Arab investigations of both sexuality and human passions" and simultaneously as an offensive against "present configura-

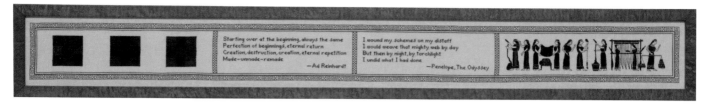

7. Elaine Reichek. *Sampler (Starting Over)*. 1996. Embroidery on linen,
8³/₄ x 67¹/₂" (22.2 x 171.4 cm). The Museum of Modern Art, New York.
Marcia Riklis Fund

tions, or popular perceptions of that culture."[15] One agenda of
Amer's work, then, is to celebrate Arab culture, much belittled
in the West, by setting parts of its literary history before Western
eyes; at the same time, she also confronts the conservative
currents in contemporary Islam by restoring to visibility parts
of its written tradition that were integral to it in the past.

Issues of gender are central to Amer. In *The Definition of Love
according to Le Petit Robert* (1993; plate 7), for instance, she
embroiders the well-known French dictionary's explanation of
the word "*amour*" on canvas, using thread, she says, because it
is "the women's tool 'par excellence.'"[16] Drawing or writing with
a needle is a strategy Amer shares with a number of contempo-
rary Western artists, some of whom have chosen it for similar
purposes.[17] The New York artist Elaine Reichek, for example,
practices a conceptually informed kind of embroidery, making
works like *Sampler (Starting Over)* (1996; fig. 7), in which carefully
sewn quotations of lines from Homer, words and images by
Reinhardt, and a design from an ancient Greek vase frame
Penelope, the legendary weaver of the *Odyssey*, as "the first
process artist."[18] Just as, in aligning Penelope with Reinhardt,
Reichek's *Sampler* addresses issues of gender and the writing
of art history, Amer's *Definition of Love* encroaches on the male
field of Abstract Expressionism: while Reichek neatly embroiders
the black panels of Reinhardt's work, Amer mimics the "drips"
of Jackson Pollock with a cobweb of loose threads, informal
lines stitched and stretched all over the canvas. If Amer should
clearly be seen in part through the lens of Arab culture, that
view must be complemented with an awareness of her context
in contemporary Western art. She was only eleven years old
when she moved to France, and if she later settled in New York,
it was because she wanted to be seen as an "international"
artist, rather than as "Egyptian or Middle Eastern or French."[19]

In Houshiary's hands, then, Islamic calligraphy becomes
invisible or illegible text, a hermetic sign, a grain of abstraction.
"Transcending name, nationality, cultures," in her words, she
buries the ethnic mark.[20] Koraïchi's invented ideograms similarly
maintain a genetic link to Islamic banners but translate them into
code, replacing public religious invocation with a private narrative.

Ataman, always favoring the exceptional over the norm, uses a
marginal calligraphic tradition to make irreverent animations in
which text morphs into image. He makes calligraphy a malleable
tool of subversion. Neshat retains a facade of tradition but com-
plicates and contradicts the expectations associated with it. And
Amer turns her back on Arabic script, using crude Roman letters
that explicitly distance her from the elegance of Islamic calligra-
phy. The means and strategies of all these artists defy tradition
and align them with contemporary practices.

Beyond Miniature Painting

When **SHAHZIA SIKANDER** took up the study of miniature
painting as an art student in Lahore in 1988, Pakistani artists had
long considered this time-honored form an anachronism. "It
supposedly represented our heritage," she says, "yet we reacted
to it with suspicion and ridicule. I had grown up thinking of it
as kitsch." In this context Sikander's decision to study miniature
painting "was an act of defiance."[21] Right from the beginning,
her transformation of the miniature capitalized on its innate,
preexisting hybridity, which, however, she extended by incorpo-
rating in it both personal content and references to Western
modernism. In *Perilous Order* of 1997 (plate 9), for instance,
Sikander depicts a friend in the guise of a Mughal prince or
emperor, one of the Muslim rulers of India. This one, though,
Sikander surrounds with figures from Hindu mythology—*gopis*,
worshipers of Krishna, derived from a miniature of the Basohli
school, which flourished in northern India during the seventeenth
and early eighteenth centuries.[22] The dots regularly punctuating
the surface meanwhile recall a regime of repetition that she
associates with Minimalism. Finally a pure invention of Sikander's
hovers in the lower center: the shadowy silhouette of a female
figure, perhaps an alter ego, with roots in place of feet—inter-
connected roots that absorb energy only from themselves,
suggesting that this woman is self-nourishing.

In *Pleasure Pillars* (2001; plate 10) Sikander again embraces
heterogeneity. Dancing figures drawn from Mughal miniatures, a
classical Venus matched by a figure of the Hindu goddess Devi,
a self-portrait with spiraling horns, the high-tech war machinery

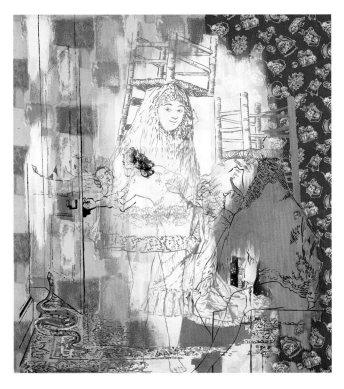

8. Sigmar Polke. *This Is How You Sit Correctly (After Goya and Max Ernst).* 1982. Acrylic on fabric, 6' 6 3/4" x 70 7/8" (200 x 180 cm). Museum Frieder Burda, Baden-Baden

of a modern fighter plane, and battling animals plucked from miniatures of Iran's Safavid period form the elements of a narrative without a story line. For Sikander these layers of ideas, or thought processes, create "open-ended possibilities."[23] Her art education, it should be remembered, did not stop in Lahore; having moved to the United States in 1993, she studied at the Rhode Island School of Design, where she was exposed to semiotics and post-Structuralist theory. Among the Western artists she admires is the German painter Sigmar Polke, who similarly mixes images of varied origins in an attempt to destabilize fixed meanings (fig. 8). The comparison with Polke, Sikander comments, "rarely comes up in conversations," but she "studied his work to understand layering paint and narrative."[24]

Sikander's work reflects the issues and events of today's world. Post–9/11 politics seep in. *Web* (2002; plate 11), with its fighter planes caught in the spider's web of some dusty, oil-rigged corner of the globe, could be a poet's antiwar editorial. The context suggests a new interpretation for the traditional motif of a lion devouring a deer. The series 51 Ways of Looking (2004) sees Sikander finding argumentative possibilities in abstraction, if, in some cases, abstraction showing traces of

representation. In *#2* (plate 12), for instance, a floral border recalling Islamic book illustration frames a rectangle of monochrome black that conjures a modernist art history running from Kazimir Malevich to Reinhardt. In the next drawing in the series (plate 13) the border breaks down: the black center overflows into the margin while the margin grows into the center. This mutual intrusion invites metaphoric interpretations to do with other kinds of center and periphery, whether in artmaking—the relative positions of abstraction and ornament in the modernist hierarchy, say—or in the world beyond.

Elsewhere in the 51 Ways of Looking series Sikander telescopes farther into the realm of abstraction, drawing straight and curving lines that intersect to form squares, rectangles, triangles, and circles (plate 14). Such drawings recall the modernist idea of a universal language, free of any cultural association, but as if to contradict that notion Sikander points out that geometry is "fundamental to Islamic art."[25] In Sikander's work, as Eugenie Tsai has written, "Categories of culturally specific and universal have become totally irrelevant."[26] Yet another drawing from the series (plate 15) again plays on the idea that representation and abstraction are each other's nemeses: the apparently abstract elements making up a whirling, circular pattern are in fact derived from the coiffures of *gopis*, female figures in the iconology of the Krishna cult. Abstracted through reduction to their hair, disengaged from their usual narrative burden, they wheel and dance in the supposedly neutral zone of abstraction, quintessences of themselves.

The affinities between Sikander's art and the miniature tradition remain apparent even as she moves from drawing to painting to animation (plate 8). The scale of **RAQIB SHAW**'s paintings—which may be as much as fifteen feet wide—immediately distances them from the miniature, but the jewellike quality of their color, Shaw's infinite attention to their minute and multifarious details, and the presence of a note of almost hallucinogenic fantasy invite comparison to such Persian miniatures as Shah Tahmasp's Shahnameh of c. 1522–40 (fig. 9), a vision of a royal court as an earthly heaven presided over by a benign ruler. Shaw similarly, in *The Garden of Earthly Delights III* (2003; plate 16), gives his world an authority figure—but his is a haloed ibex (fig. 10), a brooding beast, and where the Tahmasp Shahnameh describes a kingdom in which the civilizing influence of a legendary shah extends to the taming of animals, Shaw glorifies libidinal excess. His Eden is governed by the id. Unlike the *Garden of Delights* (c. 1510–15) of Hieronymous Bosch, the direct inspiration for the series from which this work comes, Shaw's triptych is free of moral taboo: when man and animal copulate (fig. 11), no punishment threatens.[27] Permissive and celebratory, the work seems to advocate—in the most literal way—the generation of new, hybrid possibilities.

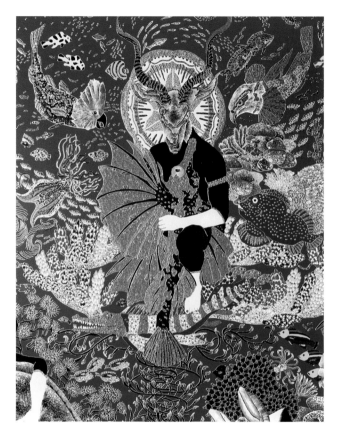

9. *The Court of Gayumars*, page from the Shahnameh painted in Tabriz, Iran, by Sultan Muhammad for Shah Tamasp. c. 1522–40. Opaque watercolor, ink, colloid silver, and gold on paper, 12 5/8 x 9 1/16" (32 x 23 cm). Aga Khan Trust for Culture, Geneva

10. Raqib Shaw. *The Garden of Earthly Delights III* (detail). 2003. Mixed media on board, three panels, overall: 10 x 15' (305 x 457.5 cm), each panel: 10 x 5' (305 x 152.5 cm). Private collection, London. See plate 16

Besides recalling the idyllic gardens of Islamic art, Shaw's Garden of Earthly Delights series may relate to the Kashmir of his childhood. "Kashmir," he says, "was named paradise by the Mughal emperor Jehangir, who said 'If there is heaven on earth, it is here, it is here, it is here.'"[28] Shaw has also spoken of the "overdose of luxury" that he knew as a child—he came from a wealthy Kashmiri family—but that he gave up for the life of an artist. He warns, however, "My work has nothing to do with what Kashmir stands for because in a sense as a child I had so many influences. My parents are Muslim, my teachers were Hindu scholars and I went to a Christian school, and historically Kashmir was Buddhist."[29] Shaw's work cannot be confined to any one geographic location. His sources range wide; he names among them Persian miniatures and Kashmiri shawls; jewellery; from Europe, old master painting and medieval heraldry; from

Japan, Hokusai prints, *byobu* (screens), *urushi* (lacquer ware), and *uchikake* (wedding kimonos); and many hours in natural history museums and libraries.

Having studied at London's Central Saint Martins College of Art and Design, Shaw is well versed in modernist art history. In Pollock, for example, he admires the discovery of a medium or technique, and the balance the American artist struck between getting lost in that medium and knowing and controlling what he was doing.[30] Shaw too has discovered a medium, a cloisonné technique in which he pours enamel paint onto a board, then draws in it with a porcupine quill. Also like Pollock, he works with an allover structure in which a dizzying sea of detail produces abstraction. At the same time, he is interested in the tension between abstraction and description—but the narrative must be pursued and sought out. The viewer is the seeker in a game of

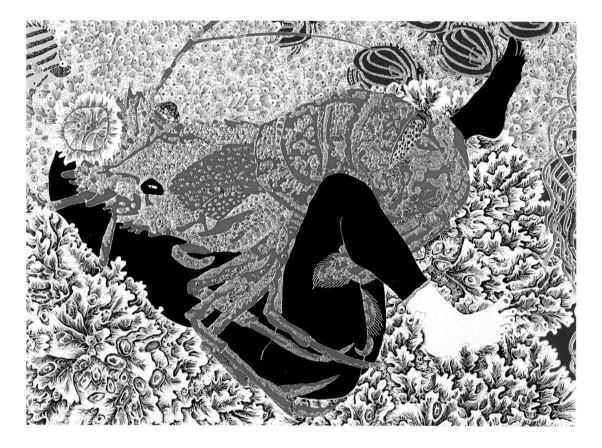

11. Raqib Shaw. *The Garden of Earthly Delights III* (detail). 2003

hide-and-seek. By straining identification in this way, the painting discloses not a single story but the impulse for tale-telling itself.

Looking under the Carpet

Many Islamic carpets express the idea of paradise as heavenly garden, to which the Muslim prayer mat is seen as a gate.[31] **MONA HATOUM**'s *Prayer Mat* (1995; plate 18) speaks of no heaven, however, unless it be the painful threshold to heaven that some see in martyrdom or sacrificial self-immolation. From a distance the mat's thick darkness promises a surface as soft as velvet; it is actually made of upward-pointing brass pins. Into this hostile site the artist has inserted a compass, such as Muslims use to orient themselves toward Mecca in their daily prayers.

Since Hatoum herself is a Christian, her choice of subject matter in *Prayer Mat* is unconnected to her faith. Nor does it relate to her origins: the child of Palestinian exiles, she was born in Beirut, and neither Palestine nor Lebanon is particularly known for the production of carpets. The meaning of the work must then be sought elsewhere. Having gone to England for a visit in 1975, Hatoum was unable to return home as Lebanon fell into a war of ethnicities and religions that would last until 1991. Although her work, with rare exceptions, is without explicit ethnic reference, it is profoundly infused with the experience of exile. When the Palestinian poet Mahmoud Darwish asks "Who am I, without Exile?,"[32] he defines a condition that is also Hatoum's. The compass in the sculpture may then indicate the search for direction on the part of the exile, of whatever ethnicity or religion, and the pins the painful bed on which he or she must kneel. The prayer mat imagery is Islamic but the content is both personal and universal.[33]

On formal grounds too, Hatoum treads contentious turf. As a geometric floor piece in low relief, *Prayer Mat* immediately cites the work of the American sculptor Carl Andre and more generally Minimal-ism at large, even while its use of ready-made objects (compass and pins) derives from the antithetical tradition of Marcel Duchamp. The result is a hybrid offspring, perhaps with a grudge against the Minimalist parent, who would not have shared Hatoum's regard for either hand labor (the pins are handsewn into the canvas support) or referential, emotional, worldly content. Even so, both the Minimalist and the Duchampian references link Hatoum to contemporary art in Europe and the United States, as opposed to the context of Islam.

Prayer Mat has affinities with a work that in conventional terms may be the most Islamic-looking object in the exhibition, in the sense that it is visually closest to a source in Islamic art: the untitled carpet from 1996–97 by the American artist **MIKE KELLEY** (plate 17). The pattern is based on a Turkish carpet in the collection of New York's Metropolitan Museum of Art (fig. 12), and Kelley had it woven in Iran.[34] But that doesn't make it either Turkish or Iranian: the original is already a hybrid of Turkish and Persian influences,[35] and Kelley, trying "to make something that wasn't Turkish,"[36] produced an object more hybrid still by changing the ground from red to green, a color more pertinent to his own, Irish-American background than to anything in Ottoman carpets.[37] He also replaced the motifs in the central medallion with a group of the hex signs—tulip, heart, and bird—traditionally used by the Pennsylvania Dutch people of the northeastern United States to decorate houses and barns. The central, cloverlike shamrock is of course an Irish emblem, indeed a symbol of the Irish nation. Kelley's carpet may wear an oriental mask but it is fully cross-pollinated.

Like Hatoum in *Prayer Mat*, Kelley seems to be criticizing Minimalism in his untitled carpet. In fact the American artists of the 1990s attacked aesthetic proscriptions and rigid, system-based intellectual procedures of all kinds, and Minimalism was among the most visible targets. Kelley's carpet is ornamental, handmade, and hybrid—hybrid to start with and made more so by his interventions. Both he and Hatoum have taken a reference from the Islamic world—an anomaly for both artists—and turned it against a Western aesthetic authority. At a time of escalating global divisions, Kelley's carpet has an added meaning: as a combination of orientalism and Americana, it undermines those who base quick identifications and analyses on a supposedly "Islamic" appearance.

The carpets of **SHIRANA SHAHBAZI** render the rubric "Islamic" even more problematic. Born in Iran, Shahbazi lives in Zurich and travels the world taking photographs that she then transfers into a variety of different mediums including carpets. Subjects she may photograph in Zurich, Harare, or Shanghai

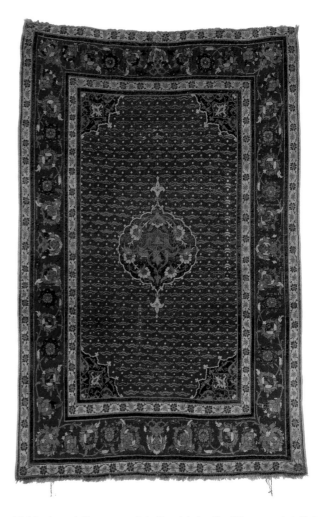

12. Islamic medallion rug, made in Egypt during the Ottoman period. Early 17th century. Wool, 6' 7" x 48" (200.6 x 121.9 cm). The Metropolitan Museum of Art, New York. Gift of Joseph V. McMullan

(plate 22) join a global tribe of itinerant signs that migrate among mediums. The young Swiss woman in *[Woman-02-2003]* and *[Farsh-01-2004]* (plates 19 and 20), for instance, appeared first in photographs that bear a family resemblance to advertising images and that Shahbazi passed to Iranian billboard painters whom she flew to Venice for the 2003 Biennale. There the artists converted the images into murals, oversized contemporary Madonnas—a reference clarified by the rendering of a gigantic lily, the Christian symbol of the Annunciation, on the ceiling above them (fig. 13). Incarnated next as carpets, the images have shrunk back down in size, being reduced to the dimensions of small oil paintings. Now, as portraits, still lifes, and landscapes, they invite association with classic genres of Western painting. Although they address the Islamic carpet tradition, they do not function as carpets; the change in scale, and the transfers

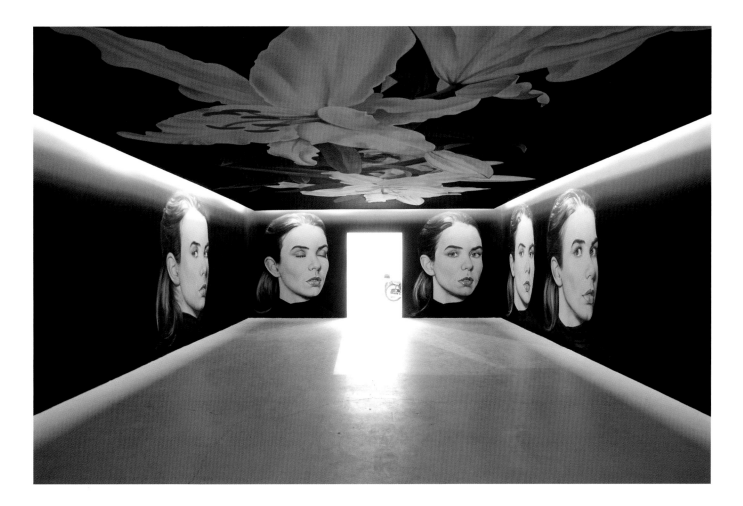

13. Shirana Shahbazi. *The Annunciation*. 2003. Installation view, *Delays and Revolutions*, Italian Pavilion, 50th Venice Biennale. See plates 19 and 20

among mediums, affirm their identities as shifting signs, as well as Shahbazi's resistance to rigid identifications and the right she claims of infidelity to any supposedly authentic origin.

Identity in Question

The notion of gender looms large in discussions of Islamic identity, which often focus on the veil worn by many Muslim women. In Western perception, the veil or chador has come to symbolize an asymmetry of power between men and women in the Islamic world. Inside that world, however, the veil confirms no single set of beliefs: *hijab* (the Islamic code of modest dress) may indeed be repressively enforced, but the wearing of the veil may also signify resistance to colonial and later secular powers, may be a relatively neutral matter of custom, may express religious faith, or may assert social status. In short the veil involves a spectrum

of meanings that shift from one geographic, historical, and social context to another.[38] It is no surprise that artists react to this array of signification in highly idiosyncratic ways.

Untitled I and II (1996; plates 23 and 24), a photographic installation by the half-Iraqi, half-Irish artist **JANANNE AL-ANI**, conveys this complexity in visual terms. In part, Al-Ani is reacting to the orientalist vision of the idle, lascivious odalisque exemplified in paintings such as Ingres's *Turkish Bath* (1862–63), or in photographs such as the Comtesse de Croix-Mesnil's *Portrait of a Mahometan Woman* (1893; fig. 14).[39] She also takes on that vision's mirror image: the fully veiled Islamic woman whom many Westerners consider oppressed. Al-Ani's work addresses, or reacts against, a construct produced in representation by the phenomenon of orientalism.[40] The artist confirms that her work is "not about an East/West binary but about the construction of that binary through Orientalist art and literature."[41]

In *Untitled I and II*, two photographs that in exhibition are installed facing each other, Al-Ani, her mother, and her three sisters perform a process of becoming: from left to right of the

Approached through the lens of her Egyptian origin, **GHADA AMER**'s embroideries of nude and near-nude women would certainly be read as subverting the expectation that the images made by a Muslim artist should conform to *hijab*. Just as Amer refuses Arabic calligraphy, she also refuses portrayals that follow the dress code of conservative Islamic culture—but it would be more accurate to say the dress code of virtually *any* culture, since she has lifted these images from pornographic magazines. Yet the figures in works like *Eight Women in Black and White* (2004; plate 26) are in fact veiled in a way, by embroidery, tangles of thread, the pentimenti of stitching. Part obscured by a casual allover pattern evoking Abstract Expressionism, they only become clear to us through their insistent repetition, a device recalling Minimalism. Moments in modern art that are mostly associated with male artists are reconciled through a medium perceived as the domain of women.

Amer opposes any ideology "denigrating the female body by trying to make it asexual," be the beliefs fundamentalist (of any religious faith) or feminist in persuasion.[44] Showing two women four times each, in a device that besides its art-historical references evokes the repeat patterns of the decorative arts, *Eight Women* most clearly illustrates the head and flowing hair of one of the figures, and the phallic fingers around the hips of the other. (Amer has said that back in Egypt, "Everything is so hidden that if you have a finger out, it becomes the focus of sexuality.")[45] Figure by figure, Amer seems to be stitching a model free of the puritanism of any culture.

Some see **SHIRIN NESHAT** as the Islamic artist above all others who can inform the West about the status of women in the Islamic world. Neshat has protested, "By no means do I feel like any kind of an expert or ambassador of [either Islam or the West], but as an Iranian living here, I feel I am invested in this whole dichotomy."[46] Americans and Europeans have mistaken Neshat's work for documentation of the oppressed condition of women in Islamic societies; her compatriots in Iran, meanwhile, have criticized it as remote from the truth. It should be noted that the scenarios she stages project visions brewed in exile, obsessions and hopes revolving around a homeland turned alien in her absence. Between Neshat's departure from Iran in 1974, for the United States, and her first return visit in 1990, the Islamic republic had become firmly established. She explored the new codes of behavior in the Women of Allah series discussed earlier.

In *The Last Word* (2003; plate 38), a photograph related to a film of the same title, Neshat choreographs two actors in a scene from her own autobiography.[47] We see an interrogation. A power struggle is evident, in which the middle-aged male interrogator draws authority from the pile of archaic manuscripts stacked in front of him, and from the underworld opacity of the space in

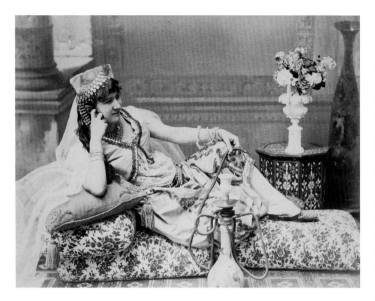

14. Comtesse de Croix-Mesnil. *Portrait of a Mahometan Woman* from *Femmes d'Orient*. 1893. Photograph. Victoria and Albert Museum, London

row in which they sit, each woman is progressively less veiled, so that they range from fully concealed on the far left to bareheaded on the far right. In charting the move from one condition to another, Al-Ani reveals the artifice in the construction of Islamic identity—a demonstration that she strengthens by her decision to show one woman's bare knee, sign of a totally different dress code, in the lower half of each panel. Almost cinematically, a flux is made visible: the ebb and flow of identity. The two photographs are not exact mirror images; the order in which the women sit is reversed from one picture to the other, so that the woman who is completely revealed in one panel is completely veiled in its twin, and vice versa. The result is that Al-Ani's Irish mother disappears in one image into the Islamic role and appears in the other as a middle-aged white woman with cropped hair, an image that, as the artist points out, invites no orientalist fantasies.[42]

By insinuating herself in the scenario, Al-Ani adds to its meaning: both photographing and being photographed, she plays a double role. The visitor who must walk through the corridor between the two pictures, and be surrounded by gazing women on both sides, is similarly both viewer and viewed. Al-Ani has said, "In my work on the veil, I confront the notion that the veiled subject is passive, oppressed, and voiceless. I try to shift the relationship between the position of the viewer and the viewed, so the veiled person is in an empowered position, seeing without being seen."[43] With *Untitled I and II* Al-Ani returns the power of the gaze to the observed. In describing the performance of a gradation of identities for the camera, the work explores the orientalist narrative in photographic history.

which he is conducting his proceeding—a cavernous darkness conjuring both the terror of bureaucratic officialdom and the trauma of the female character facing her accuser. In the film, she responds with a poem by Farrokhzad that ends with the words "I am joined to the sun." It is significant that this woman wears no veil; she could be of any nationality or faith, and the scene could be taking place anywhere courts operate in secrecy. To read the woman's identity as generically Islamic is to fall into the trap of preconceptions.

In 2000, while **MARJANE SATRAPI** was living in exile in Paris, she took up the thorny subject of identity as it is both defined and contested in postrevolutionary Iran. She did so by telling her own story—with a great deal of humor—as a child living under the Islamic regime that had toppled the Pahlavis. The medium was the comic book and its title was *Persepolis.* That city was the capital of the Achaemenid empire, which was centered in what is now Iran from the sixth century until the fourth century B.C.—a high point in the history of pre-Islamic Persia. In calling her series "Persepolis," then, Satrapi invokes a history that extends back in time far beyond 1979, and beyond the Islamic regime with which Iran has come to be identified.

Satrapi's combination of text and image can be seen as a device shared with the illustrated manuscripts of Islamic art, but she acknowledges that her "big revelation" was Art Spiegelman's graphic novel *Maus* (1986), which tells the story of his father's experiences as a European Jew during World War II.[48] Satrapi's first book, *Persepolis: The Story of a Childhood* (2003), is an account of growing up in a country torn first by the revolution and then by the eight-year war with Iraq; the second book, *Persepolis 2: The Story of a Return* (2004), begins with her departure for Austria in 1984, at the age of fifteen, sent there by her parents to attend a Catholic boarding school. The "Kim Wilde" chapter illustrated here (plates 27–35) comes from the first book, originally published in French and so far translated into sixteen languages (but not Persian).[49] The year is 1983, the revolution is four years old, the artist is thirteen, the war with Iraq is raging, and government-supported "guardians of the revolution" are ubiquitously present, looking into every nook and cranny of public space to promote virtue and prevent vice, including the temptations of behavior perceived as Western. The Iranian poet Ahmad Shamlu (1925–2000) wrote of this period,

> They smell your breath
> Lest you have said: I love you
> They smell your heart:
> These are strange times, my dear[50]

The teenage Satrapi's parents become her accomplices, smuggling into the country for her a cool denim jacket, a

Michael Jackson button, and posters of the '80s English pop star Kim Wilde and the metal band Iron Maiden. Wearing the jacket, the button, and her "1983 Nikes," the young Satrapi decides to take a step toward her dream of being a "kid in America" (following a well-known Wilde lyric) by buying some tapes—a selection ranging from "Estevie Vonder" to "Jichael Mackson," all sold clandestinely on the streets, as drugs would be in New York. As she is happily heading home, her denim jacket and "punk" shoes attract the attention of the guardians. Stopped, she is interrogated: "What do I see here? Michael Jackson! That symbol of decadence?" "No," she replies, "it's Malcolm X, the leader of black Muslims in America." She lies for survival. The passage shows the porosity of cultural borders but also speaks poignantly of the ravages of an internal war of cultures, a double set of values resulting in identities only half embraced. Satrapi is just as critical of the narrow, rigid vision of the nuns in her Austrian boarding school. Her description of alienation at home and exile abroad resonates beyond her personal history.

The head cover required of women by the Islamic regime in Iran is by no means universally mandated in the other countries of the region: in Turkey, for instance, where Satrapi's mother shops for goods to smuggle back home, she is seen wearing no veil. The men and women in the Palestinian communities taped by the conceptual artist **EMILY JACIR** in her video *Ramallah/New York* (2004–5; plates 36 and 37) likewise dress in secular modern clothing. Here Jacir, whose work is inextricably linked to her identity as a Palestinian, pairs two video screens, one showing views of Palestinian communities in New York, the other of Ramallah, in the West Bank, the two cities in which she has lived during the past six years. But she offers no obvious clue as to which is which—travel agency, deli, or convenience store, they could all be in either place. A male hairdresser cuts a woman's hair; young people of both sexes mix freely in a restaurant and bar—on both screens. Contrary to popular belief in the United States, the one society seems no less open and contemporary than the other.

Ramallah/New York moves beyond gender issues. The travel agency, a location that returns more often than the others, points to the importance of travel for Palestinians, a widely scattered people. An image of Christ and the Virgin Mary posted in a convenience store reveals that its Palestinian owners are Christian. Jacir's documentary addresses the lives of Palestinians whose relationships, life-styles, and above all their claim to an ordinary identity contradict the stereotypes propagated by the media, whether CNN or Al-Jazeera. Shown as twin cities, Ramallah and New York look virtually indistinguishable.

The veil is not the only cipher of Islamic identity; in *Keffieh* (1993–99; plate 25), **MONA HATOUM** turns to the headscarf

traditionally worn by Arab men—but the pattern of Hatoum's keffieh is embroidered using strands of women's hair, in an interweaving of the two genders in one fabric. Hatoum recognizes "a kind of quiet protest" in the art of embroidery, which, like Reichek and Amer, she specifically associates with women.[51] In *Keffieh*, then, she is subtly giving women visibility, through both the work's medium and its technique. And she is engaging women's voices in a garment that she sees as "a potent symbol of Arab resistance,"[52] and one that, as "a symbol of struggle, . . . has a definite macho aura around it."[53] Along with *Prayer Mat*, *Keffieh* is one of Hatoum's few works with an ethnic reference.

Beside deflecting machismo with a feminine intervention, Hatoum neutralizes another duality, this one visual: the regular, meshlike pattern of the keffieh is both constituted and outgrown by something literally organic, the women's hair that in places overruns the work's edges to spread beyond them in curls and tufts. In making political art, Hatoum does not sacrifice matters of aesthetic form but enlists their oppositional possibilities. That central pattern, while traditional for keffiehs, also recalls wire fencing, directing our attention to issues of land, home, and territory—topics of vital importance to Palestinians. But Hatoum addresses those issues metaphorically and through the intimation of the uncanny, making a familiar object seem strange and uncertain. The late Edward Said once wrote of Hatoum, "No one has put the Palestinian experience in visual terms so austerely and yet so playfully, so compellingly and at the same moment so allusively."[54]

The Lebanese artist **WALID RAAD** takes the identity debate in the direction of fiction, pushing truth into sly falsehood, authenticity into fabrication. Raad works in many mediums, including film, text, and performance, but his most frequent accomplice is photography, perhaps just because the photograph has so often been seen as as a neutral, accurate documentary record. Simulating the roles of historian, archivist, and reporter of facts, Raad works repetitively and serially, as many Western photographers have done. Concealing both his artfulness and himself, he hides behind a putative collective, The Atlas Group, supposedly founded to research and document the contemporary history of Lebanon, and in particular the civil wars of 1975–91. The Group keeps archives in Beirut, Raad's native city, and New York, where he lives and teaches. It was founded in 1967, 1976, or 1999, depending on what you are reading;[55] the contamination of fact by error is part of Raad's intention, reflecting an effort to sap the authority of the writers of history. Making frequent appearances in his work, for example, are documents supposedly bequeathed to The Atlas Group's archives by a "Dr. Fakhouri," "the most renowned historian of Lebanon" until his death, in 1993.[56] Dr. Fakhouri is actually an invention of Raad's.

Among the documents preserved in the archives is the group of photographs titled *Civilizationally, We Do Not Dig Holes to Bury Ourselves* (2003; plates 39–62). An accompanying statement announces that these images, "the only photographs of Dr. Fakhouri," are "a series of self-portraits he produced during his one and only trip outside of Lebanon, to Paris and Rome in 1958 and 1959." Rumor has it that the actual photographer was Raad's father, who took these self-portrait snaps (which in some cases the artist has scanned or otherwise manipulated) during trips of his own.[57] Truth dissipates, deceptions spread—but Raad has discussed his work in terms of the "false binary of fiction and non fiction."[58] Even if the photographs actually show the artist's father on trips to Europe, in some no less convincing way they may also represent the fictive Dr. Fakhouri, a Lebanese historian visiting the grand landmarks of the colonial civilizations. They may also be telling as mnemonic records of the times before 9/11, when a Middle Eastern visitor could pose innocently and unbothered against the monuments of the Western capitals. As straightforward fact the photographs suppress tensions that in other dimensions they may reveal. Behind these innocuous tourist snapshots lurks a charged narrative.

On Spirituality

Grabar has argued that the word "'Islamic' does not refer to the art of a particular religion"—that "works of art demonstrably made by and for non-Muslims can appropriately be studied as works of Islamic art."[59] In this polarized moment, the term may seem too tightly tied to the religion of Islam to allow any secular meaning, but artists from the Islamic world are by no means all practicing Muslims or for that matter Muslims at all. The art in *Without Boundary* rarely refers directly to personal religious beliefs, but a sense of spirituality does appear, not necessarily anchored in any one creed.

The work of **KUTLUG ATAMAN** offers little insight into what his faith might be. Whether his subject is a Turkish opera singer, an Englishwoman with a passion for amaryllis plants, or a German moth-collector, his art in general testifies to an interest in unusual people, and so to a desire for pluralism. *Twelve* (2003; fig. 15) should be viewed in this context: it revolves around interviews with six members of the Alevite community, a Shiite subgroup—and in Turkey, a secular country with a Sunni majority, Shiites are already a minority themselves. The Alevites believe in reincarnation and the transmigration of souls. Ataman's six interviewees meld their past and present lives in seamless narratives, and in the context of his work this video installation highlights, in his own words, the idea that "all documentary is a narrative and all narrative is constructed. All narrative, hence all lives, are in the end created as art by the subject."[60]

A more personal approach to religion, or at least to events implicating it, appears in Ataman's *99 Names* (2002; plates 63

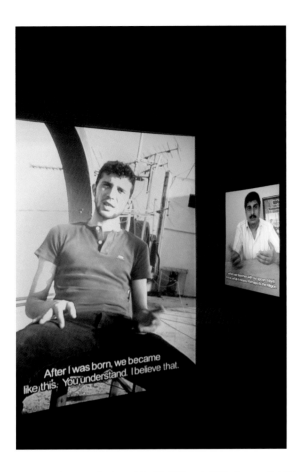

15. Kutlug Ataman. *Twelve*. 2003. Six DVDs, six DVD players, six LCD projectors, six directional sound panels, six quartz-crystal high-contrast rigid rear-projector screens, six benches, each DVD c. 45 minutes. Installation view

and 64). This uncharacteristic but compelling work took shape during the period of escalating worldwide extremism after 9/11. "When I made this piece," says Ataman, "I was inspired by the ninety-nine names of Allah, who is described in terms of ninety-nine qualities."[61] These qualities attributed to Allah cover a territory that Ataman compares to the trajectory between the id and the superego. In his five-screen video installation, which echoes the motions of Sufi rituals, a man appears in various stages of meditation. Where the characters in Ataman's documentaries are usually loquacious, talking endlessly as they revise their lives for the camera, the protagonist of *99 Names* is silent, and moves from quiet introspection in the first screen, through stages of increasingly visible agitation, to literal chest-beating in the final screen. An inner force, which Ataman characterizes as sexual, fuels his energy until he loses control.[62] This hypnotic spectacle offers an intimate experience of an altered state but leaves the door open to interpretation. In some installations of *99 Names*, the screens are installed on different, progressively

higher levels in the space, so that the man appears to take flight. The screens may also be set up so that his pounding movements seem directed against the architecture around him. Is this eruption, we may ask, an ecstatic experience or a baring of the darker side of humanity? Is his violence the logical conclusion of following a certain path or the result of a deviance from it? *99 Names* is Ataman's visceral response to 9/11.

The expression of spirituality need not be linked to any specific faith. As it was written by the thirteenth-century Persian poet and mystic Jalal al-Din Muhammad, also known as Mawlana and as Rumi,

> What is to be done O Moslems? For I do not recognize myself
> I am neither Christian, nor Jew, nor Gabr, nor Moslem
> I am not of the East, nor of the West, nor of the land, nor of
> the sea
> I am not of Nature's mint, nor of the circling heavens . . .
> I am not of India, nor of China, nor of Bulgaria, nor of Saqsin
> I am not of the kingdom of Iraqain, nor of the country of
> Khurasan . . .
> My place is the Placeless, my trace is the Traceless
> 'Tis neither body nor soul, for I belong to the soul of the
> Beloved
> I have put duality away, I have seen that the two worlds are one
> One I seek, One I know, One I see, One I call[63]

Houshiary, the Iranian painter **Y.Z. KAMI**, and the American video artist Bill Viola all draw strength and inspiration from Rumi and from other spiritual masters and poets. All proceed with an eye turned inward. This shared interest is striking in the context of this essay, which sets out to deflect the old concepts of "Eastern" and "Western" and to affirm the common humanity confined by this binary structure.

Kami's portraiture may describe outer surfaces but seeks the inner life, what the artist calls "the soul." A face for him is a site of epiphany, in the sense defined by Emmanuel Lévinas, whose classes Kami attended at the Sorbonne, Paris, in the late 1970s.[64] A Kami portrait, then, is rarely about the sitter; each appearance pertains to something larger—a sense of some overall human self. Kami's paintings create a human kinship, turning solitary individuals into a fraternity, a tribe, the community of humankind.

Kami often conceives his portraits in series, though each one is highly individualized. The works of the early 1990s were inspired by Fayum portraiture, painted in Egypt in the first-to-third centuries A.D. as funerary imagery, and therefore intimating associations of mortality. In the series of the past decade, there are figures that blur, tremble, and visually withdraw. Their retreating presence, however, remains as intense as that of the other,

fully focused portraits. These series encourage meditation on the flow between presence and absence, and on impermanence and change.

For the series to which the two works in *Without Boundary* belong, Kami began by photographing visitors to a meditation center in Vermont. His paintings treat the people he met there with old master grandeur. Speaking in terms of Jungian archetypes, Kami likens the female figure here (2004–5; plate 65) to Sophia, "the woman wisdom of God," also understood as the mother of God.[65] Her regal serenity, Kami acknowledges, also recalls the Madonna of Piero della Francesca's Misericordia polyptych (fig. 16).[66] The companion picture (2004–5; plate 66), an archetype of a different gender and age, is equally simple and serene. The series featuring these two figures, the former fully present and the latter on the threshold to elsewhere, passes from Christian to Eastern modes in its spiritual references, transcending geographic boundaries. The subdued palette and dry, frescolike quality of the surface reinforce the paintings' aura of sanctity.

Kami's vocabulary derives not just from old master painting but from the academic realist art of his native Iran. Initially derived from Europe, and embraced in part in reaction against the abstraction of traditional Islamic art, this kind of work, dis-

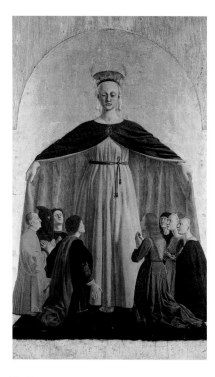

16. Piero della Francesca. *Polittico della Misericordia* (Misericordia polytypch; detail). 1445–62. Oil and tempera on panel, 8' 11 1/2" x 10' 9 15/16" (273 x 330 cm). Museo Civico, Sansepolcro

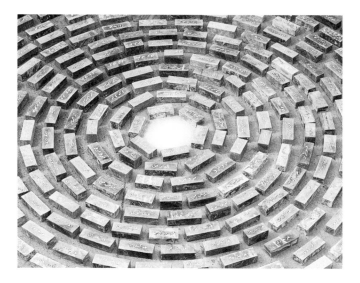

17. Y.Z. Kami. *Rumi, The Book of Shams e Tabrizi (in Memory of Mahin Tajadod)* (detail). 2005. Soapstone, salt, and lithography ink, dimensions variable

seminated in Iran between the late nineteenth century and World War II, was associated with the West and with modernism.[67] Kami learned it from a student of a student of Mohammad Ghaffari, or Kamal-ol Molk (1848?–1940), the best-known artist of this genre. Aesthetic lineages of this sort complicate such labels as "contemporary Islamic art," which obscure the intervening period of "post-Islamic" modernisms.

Besides painting in a figurative style, Kami also makes sculpture, and in a more abstract idiom. In both bodies of work he remains close to the teachings of mystical thinkers and poets. In *Rumi, The Book of Shams e Tabrizi (In Memory of Mahin Tajadod)* (2005; fig. 17), for example, he ink-stamps on soapstone bricks the words of a repetitive, rhythmic poem by Rumi: "Come, come my beloved, my beloved,/Enter, enter into my work, into my work!" Rumi is said to have often composed to music while performing the *sama*, the mystical Sufi dance.[68] Emulating the whirling movements of the dance, Kami makes each of Rumi's words a building block in a series of consecutive circles—each circle, repeated, becoming part of a larger constellation. In his abstraction as in his portraiture, Kami approaches the universal by examining the specific.

In any kind of thinking concerned with the grand scheme of things, dualities exist only to be surmounted. The most extreme of all dualities, being and not-being, blend in the work of **SHIRAZEH HOUSHIARY**. *White Shadow* (2005; plates 71 and 72), executed with the British architect **PIP HORNE**, is a sculpture that aspires to be absent: between being and nonbeing, Houshiary says, "Its form is in a state of flux."[69] It is constructed in such a way that its presence is incomplete—is an absence—

and the artist describes it in terms of "absence of form, absence of mass and presence of shadow."[70] The form soars into space only to seem to remove itself and disappear, like a ghost. It becomes apparent through light while simultaneously converting light into shadow. As it dances around its skeletal axis, it too is engaged in the *sama*.

In its formal heritage too, *White Shadow* confirms confluence rather than opposition, fusing influences that range from the spiral minaret of the Great Mosque of al-Mutawakkil in Samarra, Iraq (fig. 18), built in the ninth century A.D., to Constantin Brancusi's *Endless Column* (1937; fig. 19), in Târgu Jiu, Romania. The work is also the most recent addition to a series of towers created by Houshiary and Horne—the last of them, tellingly, in the vicinity of the absent Twin Towers of the World Trade Center in Manhattan. The contradictions of tradition and modernity, the spiritual and the scientific—or of Islamic and not—evaporate in these structures, which erase such oppositions. In the physical structure of the towers, the artists animate the double helix of human genetics with the dance of a whirling dervish.

Like Kami and Houshiary, the American artist **BILL VIOLA** is well versed in the mystical literature of Europe and Asia. In particular, Viola has said that he considers Rumi a "supreme source of inspiration."[71]

Viola has related the video diptych *Surrender* (2001; plates 67–70) to the teachings of Rumi.[72] Two vertically stacked screens show images of a man and of a woman, each image placed to suggest a mirror reflection of the other. As if seeking to merge, the two figures bow in each other's direction. Each prostration brings them closer to each other, until they finally seem to touch—at which point we realize that the images we are watching seem to be reflections in water, which breaks into shimmering ripples that dissolve into abstraction. Discussing this work, Viola quotes Rumi: "He who sees only his own reflection in the water is not a lover."[73] Viola's search beyond the reflection unites him with Kami, who looks to the surface for something beyond the world of appearances. Houshiary similarly seeks "to capture the substance or the essence of things rather than the thing itself."[74] All of these artists observe human life with awe and compassion.

The artists joined in *Without Boundary* are a widespread, disparate group in art's global mainstream. They come from Algeria, Egypt, India, Iraq, Iran, Lebanon, Pakistan, Palestine, and Turkey, and their works manifest both ruptures and links with their places of origin. But the exhibition reveals what they share: a tie based not in ethnicity or religion, but in their way of revising, subverting, and challenging the aesthetic traditions they deal with, and of bringing preconceived notions of cultural homogeneity to ruin. Their close juxtaposition in *Without Boundary* reveals the idiosyncrasies of their personal approaches, and therefore the fallacy

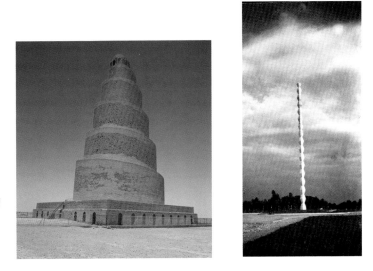

18. Minaret, Great Mosque of al-Mutawakkil, Samarra, Iraq. 848–52

19. Constantin Brancusi. *Endless Column*. 1937. Cast iron and steel, 98' (29.8 m) high. Public sculpture, Târgu Jiu, Romania

of basing our perceptions of them—as artists, as people—on a single collective difference.

Where calligraphy rubs elbows with the digital and *gopis* with abstraction, where carpets shrink to the size of an academic still life and where the small-scale exactness of the miniature fills an immense allover surface, we are no longer in territories defined by origin or by Western traditions. Rather, we face erased borders and an expansion of the pool of signs and references, a world of new possibilities. The tales these artists tell have of course sprung from specific situations, but their modes of expression take into account other histories and perceptions. A critique of calligraphy, for instance, may also subvert Abstract Expressionism; exile may be explored through a language that undermines Minimalism; a comic book may host stories from an Islamic revolution; veiled women may unsettle the Western gaze. Such complexities bar the use of "Islamic" as a term of convenience. "European" or "American" are equally inapplicable. The rich texture of expression exceeds the binary opposition.

And this is the reason for bringing these artists together, although they belong to no one culture and have neither initiated nor constitute a movement or school. Pointing to a phenomenon one might call Post-Orientalism, they resist essentialist notions of who they are. Their multifaceted selves speak not collectively but individually. Maintaining the freedom to criticize as well as to celebrate, they belie the mentality of division. They are unconcerned with the binary oppositions of present-day politics, whether cultural or global—including "Islamic or not."

Notes

1. For an introductory description of the "Islamic world" see Melise Ruthven with Azim Nanji, *Historical Atlas of Islam* (Cambridge, Mass.: Harvard University Press, 2004), pp. 16–17. See also Ira M. Lapidus, *A History of Islamic Societies* (Cambridge: at the University Press, 2002), and Reinhard Schulze, *A Modern History of the Islamic World*, trans. Azizeh Azodi (New York: at the University Press, 2002).

2. The term "Islamic," which in aesthetic discourse was until recently applied mainly to the traditional arts of the Islamic world, is now being applied to modern and contemporary art. See, for instance, Wijdan Ali, *Modern Islamic Art: Development and Continuity* (Gainesville: University Press of Florida, 1997). At Middlebury College, Vermont, a course on "Approaches to Islamic Art" addresses "the issue of contemporary Islamic art." The University of Minnesota offers a course on "Contemporary Islamic Art and Architecture" that deals with Shirin Neshat and Mona Hatoum. The same artists are called "Islamic" in Charles Giuliano, "Shirin Neshat and Mona Hatoum," *Art New England* 23, no. 3 (April–May 2002): 9.

3. See Oleg Grabar, *Penser l'art islamique* (Paris: Institut du monde arabe, 1996), p. 25. With Reinhard Schulze, Grabar traces the first discussion of art as "Islamic" to Moriz Carriere, *Die Kunst im Susammenhang der Culturentwickelung und die Ideale der Menschheit*, 5 vols. (Leipzig: Brockhaus, 1863–73).

4. Grabar, personal communication with the author, 2005. See also Grabar, *The Formation of Islamic Art* (New Haven and London: Yale University Press, 1973).

5. On calligraphy see Annemarie Schimmel, *Islamic Calligraphy* (Leiden: Brill, 1970); Schimmel, *Calligraphy and Islamic Culture* (New York and London: New York University Press, 1984); Yasin Hamid Safadi, *Islamic Calligraphy* (New York: Thames & Hudson, 1987); and Nabil F. Safwat with a contribution by Mohamed Zakariya, *The Art of the Pen: Calligraphy of the 14th to 20th Centuries* (London: The Nour Foundation in association with Azimuth Editions and Oxford University Press, 1996).

6. In Iran, for instance, the stylistic flexibility of calligraphy allowed it to accommodate itself to the indigenous modernist art that began to thrive in the 1960s. See Fereshteh Daftari, "Another Modernism: An Iranian Perspective," in *Picturing Iran: Art, Society and Revolution*, eds. Shiva Balaghi and Lynn Gumpert (London and New York: I. B. Tauris, 2002), pp. 39–87. On calligraphy in the Arab world see Silvia Naef, "Reexploring Islamic Art: Modern and Contemporary Creation in the Arab World and Its Relation to the Artistic Past," *RES* 43 (Spring 2003): 164–74. In "The Post Modern Turn in Islamic Calligraphy," a paper delivered as part of a panel on "Contemporary Art and Islam" at the annual conference of the College Art Association in 2004, Maryam Ekhtiar argued that abstraction did not enter calligraphy as the result of an encounter with Western modernism but that it was inherent in traditional forms of calligraphy written not "to be read, but to be seen and admired."

7. Shirazeh Houshiary, e-mail to the author, July 17, 2005.

8. Houshiary, e-mail to the author, September 18, 2005.

9. Rachid Koraïchi, conversation with the author, November 2005.

10. Koraïchi, conversations with the author, June 2004 and March 2005.

11. Neshat, e-mail to the author, August 22, 2005. In this context one notes the work of the Armenian-Iranian artist Sonia Balassanian, who has inscribed self-portraits, in which she wears a veil, with words in Roman letters such as "stoning" and "rape," as well as with words crossed out altogether. These works may also include found documents in Arabic script. See *Portraits by Sonia Balassanian* (New York: S. Balassanian, 1983).

12. Neshat, conversation with the author, 2005.

13. Ghada Amer, conversation with the author, 2005.

14. See Abdelwahab Bouhdiba, *Sexuality in Islam*, trans. Alan Sheridan (London, Boston, and Melbourne: Routledge & Kegan Paul, 1985).

15. Olu Oguibe, "Love and Desire: The Art of Ghada Amer," *Third Text* 55 (Summer 2001): 72.

16. Amer, quoted in Teresa Millet, "A Conversation with Ghada Amer," in *Ghada Amer* (Valencia: IVAM, 2004), p. 32.

17. See Laura Auricchio, "Works in Translation: Ghada Amer's Hybrid Pleasures," *Art Journal* 60, no. 4 (Winter 2001): 27–30.

18. Elaine Reichek, *When This You See . . . Elaine Reichek* (New York: George Braziller, 2000), entry for plate 14, n.p.

19. Amer, quoted in Millet, "A Conversation with Ghada Amer," p. 30.

20. Houshiary, quoted in Ann Barclay Morgan, "From Form to Formlessness: A Conversation with Shirazeh Houshiary," *Sculpture* 19, no. 6 (July–August 2000): 26–27.

21. Shahzia Sikander, in "Nemesis: A Dialogue with Shahzia Sikander by Ian Berry," in Berry and Jessica Hough, *Shahzia Sikander: Nemesis* (Saratoga Springs: The Tang Teaching Museum and Art Gallery, and Ridgefield, Conn.: The Aldrich Contemporary Art Museum, 2005), pp. 5, 7.

22. See Daftari, "Beyond Islamic Roots—Beyond Modernism," *RES* 43 (Spring 2003): 183, note 18.

23. Sikander, conversation with the author, 2005.

24. Sikander, e-mail to the author, August 27, 2005.

25. Sikander, conversation with the author, 2005.

26. Eugenie Tsai, "Reviews: Shahzia Sikander," *Time Out* no. 497 (April 7–13, 2005): 79.

27. Raqib Shaw's image of human-crustacean sexual relations recalls a genre of Japanese prints; see, for example, Matthi Forrer, *Hokusai* (New York: Rizzoli, 1988), p. 217, fig. 236. But Shaw's models were empirical: he writes, "The image of the human form in the painting is the silhouette of my body, and the shrimp is from a drawing that I made of a preserved specimen at the Natural History Museum." E-mail to the author, August 17, 2005.

28. Shaw, e-mail to the author, March 18, 2004.

29. Shaw, in "Raqib Shaw in Conversation with Richard Dryer," *Wasafiri* 42 (Summer 2004): 74.

30. Shaw, conversation with the author, 2005.

31. See Sheila S. Blair and Jonathan M. Bloom, *Images of Paradise in Islamic Art* (Hanover, N.H.: Hood Museum of Art, Dartmouth College, 1991), and Elizabeth B. Moynihan, *Paradise as a Garden: In Persia and Mughal India* (New York: George Braziller, 1979).

32. Mahmoud Darwish, *Unfortunately, It Was Paradise: Selected Poems*, trans. and ed. Munir Akash and Carolyn Forché with Sinan Antoon and Amira El-Zein (Berkeley, Los Angeles, and London: University of California Press, 2003), p. 113.

33. In a paper prepared for the panel "Contemporary Art and Islam," held at the College Art Association's annual conference in February 2004, Gannit Ankori described Hatoum's *Prayer Mat* as "evoking Islamic culture as well as the theme of exile," and said that it "addresses the exile's loss of direction when away from home."

34. Mike Kelley found the carpet in a reproduction, in the June 1970 *Bulletin* of The Metropolitan Museum of Art. A collage that he made of this illustration and the hex-sign images was sent to Iran for the carpet-makers to copy. Conversation with the author, November 2005.

35. I would like to thank Grabar and Massoumeh Farhad for their expertise and insight on the subject of the Met's carpet.

36. Kelley, conversation with the author, March 31, 2005.

37. Ibid.

38. See David A. Bailey and Gilane Tawadros, eds., *Veil: Veiling, Representation and Contemporary Art*, exh. cat. (Cambridge, Mass.: The MIT Press, and London: in IVA, 2003).

39. Jananne Al-Ani used this photograph as an illustration in her essay in ibid., p. 95. She was a co-curator of the exhibition that the book accompanied.

40. See Stuart Hall, "Cultural Identity and Diaspora," in Patrick Williams and Laura Chrisman, eds., *Colonial Discourse and Post-Colonial Theory: A Reader* (New York: Columbia University Press, 1994), p. 393.

The founding text here is of course Edward Said's *Orientalism* (New York: Vintage, 1979).

41. Al-Ani, in "Richard Hylton Interviews Jananne Al-Ani," in *Jananne Al-Ani*, exh. cat. (London: Film and Video Umbrella, 2005), n.p.

42. Al-Ani, conversation with the author, March 2005.

43. Al-Ani, quoted in "Jananne Al-Ani," in Sharon Kivland and Lesley Sanderson, eds., *Transmissions: Speaking & Listening* (Sheffield: Site Gallery, Sheffield Hallam University, 2004), 3:155.

44. Amer, quoted in Valerie Cassel, "Unscripted Desire: Excerpts from Conversations with Ghada Amer," in *Ghada Amer: Reading Between the Threads* (Høvikodden: Henie Onstad Kunstsenter, 2001), p. 45.

45. Amer, quoted in Auricchio, "Works in Translation," p. 30.

46. Neshat, quoted in Babak Ebrahimian, "Passage to Iran: Shirin Neshat Interviewed by Babak Ebrahimian," *PAJ*, September 2002, p. 51.

47. See "In Movement: A Conversation between Shoja Azari and Shirin Neshat," in *Shirin Neshat: 2002–2005* (Milan: Charta, 2005), p. 11.

48. Marjane Satrapi, quoted in Steven Heller, "Marjane Satrapi: A Graphic Memoir," *Eye* 13, no. 50 (Winter 2003): 76. Art Spiegelman's *Maus* was published by Pantheon, New York, in two volumes, in 1986 and 1992.

49. In the United States, both volumes were published by Pantheon, in 2003 and 2004 respectively.

50. Ahmad Shamlu, "In This Blind Alley," in Nahid Mozaffari and Ahmad Karimi Hakkak, eds., *Strange Times, My Dear: The Pen Anthology of Contemporary Iranian Literature* (New York: Arcade Publishing, 2005), p. 372.

51. Hatoum, in *Mona Hatoum: Images from Elsewhere. Week 36*, exh. brochure (London: fig-1, 2000), n.p.

52. Ibid.

53. Ibid.

54. Edward Said, *Mona Hatoum: The Entire World as a Foreign Land* (London: Tate Gallery, 2000), p. 17.

55. See Alan Gilbert, "Walid Raad," *Bomb* no. 81 (Fall 2002): 40.

56. See The Atlas Group and Walid Raad, *The Truth Will Be Known When the Last Witness Is Dead* (Cologne: Verlag der Buchhandlung Walther König, Noisy-le-Sec: La Galerie, and Aubervilliers: Les Laboratoires d'Aubervilliers, 2004), p. [9].

57. In conversation with the author in 2005, Raad would not confirm this rumor.

58. Raad, quoted in Wolf Jahn, "Atlas Group/ Walid Raad," *Artforum* 42, no. 10 (Summer 2004): 261.

59. Grabar, *The Formation of Islamic Art*, p. 1.

60. Kutlug Ataman, quoted in Carolyn Kerr, "Ataman," in *Turner Prize 2004*, exh. brochure (London: Tate Publishing, 2004), n.p.

61. Ataman, e-mail to the author, February 28, 2005.

62. Ataman, conversation with the author, 2005.

63. Rumi, quoted in Afzal Iqbal, *The Life and Thought of Mohammad Jala-ud-Din Rumi* (Lahore: Bazm-I-Iqbal, [1955]) pp. 117–18.

64. In conversation with the author in 2005, Y.Z. Kami referred to Emmanuel Lévinas's *Totalité et Infini: Essai sur l'extériorité*, 1971 (Paris: Librairie Générale Francaise, Livre de Poche, 1996).

65. See Carl Jung, *Jung on Alchemy*, ed. Nathan Schwartz-Salant (London: Routledge, 1995), p. 148. Kami guided the author to this reference.

66. Kami, conversation with the author, early 2005.

67. See Daftari, "Another Modernism," pp. 41–44.

68. Schimmel, *Rumi's World: The Life and Work of the Great Sufi Poet* (Boston and London: Shambala, 2001), p. 196. On Sufism and dance see pp. 195–204.

69. Houshiary, e-mail to the author, July 2005.

70. Ibid.

71. Bill Viola, in "Conversation: Lewis Hyde and Bill Viola," in Lewis Hyde, Kira Perov, David A. Ross, and Viola, *Bill Viola: A Twenty-Five-Year Survey*, exh. cat. (New York: Whitney Museum of American Art, 1997), p. 144.

72. See "A Conversation: Hans Belting and Bill Viola," in John Walsh, ed., *Bill Viola: The Passions*, exh. cat. (Los Angeles: The J. Paul Getty Museum, 2003), p. 207.

73. Ibid.

74. Houshiary, quoted in Morgan, "From Form to Formlessness," p. 25.

Hi! Thank you for reading me. I should be happy to be here, though I can't help feeling confused. I like the way your eyes are traveling over me. Because I'm here to serve you. Even though I'm not sure what that means. I don't even know what I am these days—isn't that a pity? I'm a concoction of signs; I long to be seen, but then I lose my nerve. Would I be better off hiding myself away in the shadows, far away, protected from all eyes? That's what I can't decide. I'm making such a big effort to be here, even with all these worries, strangely. I want you to understand this: this kind of exposition is new to me. I've never existed in quite this way. In the old days, we were more to one side. I'd love to attract your attention, but without giving it too much thought, for that is when I feel at my most relaxed. So keep me in the corner of your mind and forget I'm even there. I'd like to remind you—quietly, the way I did in the old days—how nice it was, to exist for you without your even knowing. I'm not really sure this can ever really happen, though. Because the real problem is this: I tend to think I'm a picture when really all I am is words. Because when I'm letters, I think I'm a picture and when I'm a picture I think I'm letters. But this is not from hesitation—this is my life. Let's see how long it would take for *you* to get used to it. If you ask me, the reason we can't understand each other is because the inside of your head is different. Look—the only reason I'm here is to mean something. But you look at me like I'm just an object. Yes, I know—I do have a body. But my body is only here to help my meaning flap its wings like a bird and take flight. I know from the way you're looking at me that I have this body, that my left side and my right side are decorated with colors and objects. This pleases me and

confuses me. Once upon a time, when I was just a meaning, it never occurred to me that I was also an object, and I didn't even have a mind; I was nothing more than a humble sign passing between two beautiful minds. I was not aware of my own existence, and this was lovely. You could look at me and I wouldn't think anything of it. But now, as your eyes run across us letters, I feel as if I have a body, as if all I am is a body—and a chill runs through me. Okay, I'll admit it, I like it, just a little, and I go along with it, but I also feel a little ashamed. But the moment it begins to please me, I want more and that scares me. I end up asking myself, what's going to happen next? I start worrying that my body is going to obscure my soul, and that the meaning—my meaning—will get pushed deep inside me. That's when I start wanting to hide in those shadows. That's when you can no longer understand me, and you start getting confused, and even you can't figure out if you're reading me or gazing at my body. That's when even I get scared of my body, and wish I was just a meaning, but I also know I've left it too late. There's no way I can go back to the good old days now, to the days before you arrived; there's no running back to the days when I was just a meaning. This is when I am neither fully here nor fully some-where else; instead I hover between heaven and earth, undecided. This brings me pain, and I try to console myself with bodily pleasures. I'd love to attract your attention, but without your giving it too much thought, for that is when I feel at my most relaxed. Should I be a meaning or an object? A letter or a picture? Which reminds me, I—just a minute, don't leave yet….I can't bear the thought of your turning the page yet… you still don't understand me but already you're casting me aside….

ANOTHER COUNTRY

Homi Bhabha

If you talk of Islam today, in the context of the making of visual images, your eye doesn't follow the hunt so beloved of Safavid artists; your lungs don't fill with the perfumed air of Mughal gardens and pavilions; your mind doesn't race along the calligraphic callisthenics or acrobatic geometries of dome and minaret. Today these popular images of Islamic art have lost their clement weather and their *plein air* pleasures. The age of terror that seems to have settled upon us like a chemical cloud disfigures our pictorial vision and encloses us in a harrowing chamber. It is difficult, in the West at least, to invoke "Islamic" images without calling up the Abu Ghraib album, the televised beheading of an American businessman, and many other entries in the *musée macabre* of war and terror.

The artists in *Without Boundary* offer us a way out of the prison house of the culture of torture and "security." They refuse the shuttered view in which "civilizational" polarities are set up to impede the free and fair representation of cultural differences, while political proscriptions interrupt enlightened conversations across diverse communities and societies.

It would be difficult to provide a *tour d'horizon* of a show as varied and singular as this one, and I will not be discussing all of the artists it embraces. Its most provocative gesture, however, seems to me to consist in questioning the assumptions we make about the relation between the narratives of cultural transmission and the concept of time informing aesthetic forms and artistic practices. Is there a sense of time peculiar to portraiture, and does that sense alter if the portrait is realized in photography or in embroidery? What are the connections between the time internal to the work, the historical time-period, and the temporal or historical assumptions of interpretational discourses? How is *genre* or *medium* affected by historical time and cultural temporality? Are art forms like calligraphy and digital imagery "dated"

differently? The time internal to artworks may itself articulate cultural values and political ideas, which the relations among disparate time frames may extend. Are there national or communal borders that should be respected, or rent, in translating one *form* of aesthetic time into the *shape* of another art object or the practice of another culture? What is the difference between cultural provenance and inheritance? What are the historical terms and aesthetic conditions that govern cultural transmission in a world of global disjunctures and displacements?[1]

In an age in which the global world picture is increasingly identified with the digital impulse of acceleration and immediacy—the split-second, virtual transmission of messages, money, and meaning—many of the artists in this show resort to *slower* traditions of manufacture, such as painting, embroidery, calligraphy, weaving, and portraiture. Meanwhile some combine these traditions with more contemporary processes, such as video, animation, and cartoons. The more traditional forms can be seen as slower, or time-lagged, in themselves; and another kind of time lag appears in works that combine the slower and faster forms. Fast and slow should not be understood as past and present or new and old—like the spatial descriptions of surface and depth or figure and ground, fast and slow represent figurative and conceptual dimensions of the time scheme of a work of art. These artists emphasize the *poesis* of the object or image, the very act of *making*, which renews (rather than returns to) the place of hand and gesture, the communal, quotidian spirit of the atelier, the disclosure of the agent in the midst of the object. An interest in a slower art should not be seen as an obscurantist celebration of tradition or a revival of the past. By bringing to our attention the fact that the making of the image requires the intervention of a delayed or lagged temporality, these artists disrupt the global reach of digital immediacy by introducing the issue of *mediation*:

the diverse elements or processes—each carrying its own cultural and formal signature—that come together to give a work its visual presence and its yield of pleasure.

Mediation is in part the struggle with materiality: the attempt to endow the stuff of art (paint, stone, thread, language, canvas, film) or of history (genre, period, institution) with intention, performance, gesture—in brief, an architecture of agency. But the practice of art also brings about the transformation of material into the means of singular expression or collective enunciation. This is the moment we often recognize as the "calling" of art, the moment at which production and poetry come together to address the historical world. Art is now both the stuff of materiality and the shape of singularity; it is an object in the world and a mode of address that makes the world. This double determination of art opens up spaces of social difference and alterity, while disclosing historical times in which the object has to negotiate "other," alternative temporalities. The mediation of the slower, time-lagged aesthetic forms into the digitalized forms of contemporary media practices produces a form of disjunction that enables these artists to reinvent tradition while revising the cultural history of the present moment.

Shahzia Sikander describes the creative possibilities that arise out of the time-lagged processes of cultural transmission when she describes her own technique of "layering":

> Digital process is yet another way for me to explore both formal and subjective issues within the tight parameters of the miniature. Combining a nontraditional medium with a traditional genre allows me to build a relationship between present and past, space and dimension, narrative and time—all in service of destabilization. In a miniature a slower more controlled pace is in operation. . . . The process of creation hence has a hierarchy surrounding the investment of labor, which may not necessarily be true of a digital process.[2]

The past becomes uncannily contemporary in the domain of video and virtuality. At the same time, the technological aesthetic practices of our time are provided with an active (rather than antiquarian) cultural memory that propels them into the awareness of a future that is both historically mediated and digitally manipulated.

Sikander revives the debased format of the Islamic miniature by interleaving its traditional compositional structure—"the linear interplay of . . . various forms on the surface of the painting"[3]—with a palimpsestical layering of other representational surfaces that have a modernist, postmodernist, or animationist provenance. Y.Z. Kami's "sense of antiquity"[4] gives a classical aura to his iconic, outsized portraits of contemporary, quotidian mystics.

The young woman in *Untitled* (2004–5; plate 65) has something of the intensity and idealization of Kami's earlier Fayum-style portraits, but her averted, half-closed eyes just slightly disturb and displace the center of the canvas, in a movement reminiscent of Bellini's Madonnas looking away from the divine child. Kami's method of composition in these works is a mediated transmission across materials, genres, and time exposures: a photograph of the subject taken immediately after a period of meditation is turned into a painting. From this layered archive the artist achieves a compositional repose through which his figures rest on the surface of the canvas like lotuses on a skin of water.

The Persian tradition of juxtaposing image and text is retooled by Shirin Neshat. Laying an inscriptive surface of writing over the picture-plane, Neshat "tattoos" the skin of her warlike women with decorative bodily ornamentation resembling that used in the Indian festive ritual of *mehndi*. Once again, the work depends on a process of cultural transmission that passes through the mediating materials of language, portraiture, weaponry, tattoos, and the ritual use of henna to ornament the celebrant's hands and feet. Once again we see an audacious articulation of the traditional and the technological, the horrendously timely portrayal of the body-as-weapon (plate 3) and the deceptively timeless ornament of feminine beauty and desire.

Kutlug Ataman's comedic phallic calligrams, Marjane Satrapi's use of the sitcom scenarios of the comic book to play out the black (and white) comedy of the Iranian revolution and its repressive security state—all these instances of the creative movement across time-zones and cultural borders cannot simply be understood as techniques of appropriation or strategies of revision and subversion. They serve a larger purpose. The works I have discussed slow down the hermeneutic hurry with which we try to define their time frames (what cultural value, what aesthetic understanding, comes from this intermediate state of past-in-present?) and make us delay our judgments on genres, cultural norms, and art objects (are these heterogeneous, hybrid articulations or smooth syncretic forms?). What these artists reveal is a productive yet provisional sense of transition that persists in the time-lagged process of cultural transmission: how do artistic traditions endure the process of displacement while maintaining some of the contours of cultural continuity? What transformative possibilities exist within practices that appear to be traditional and time-worn? When cultural traditions are recognized as "local," "regional," or "authentic," do we detect an element of resistance to the international art machine and market, or are these the very qualities of marginal diversity that make the most sought-after global commodities?

These questions are prompted by the way in which the works in *Without Boundary* illuminate the processes of cultural transmission. Cultural transmission does not follow the pure bloodlines of

tradition, nor do its transfigurations readily conform to the conti-nuity or culmination of an aesthetic inheritance. The skein of past and present, the pattern of residue and emergence, are sig-nified in the contestation, or conversation, between time-lagged aesthetic forms and material practices. "The quality of art is outside the historicist dimension," Shirazeh Houshiary argues. "To see the evolution of art through chronological time is a requirement of art historians and critics, but it has never been intrinsic to art."[5] The timeless state that is art's epiphany—"Art is time-less," they say—is not a loss or lack of time, nor is it an ineffable infinity. The temporal ambiguity that figures in Houshiary's *Fine Frenzy* (2004; plate 1) is only visible after a long and slow contemplation of the painting's surface. A secret, unseen word is the veiled origin of the painting, but the word is neither its "beginning" nor its deep, enclosed meaning. The labor of making consists in an insistent and repetitious overwriting ("*I have written the one word over and over*") followed by a process of erasure ("*and then have sanded the surface to become a process of erasing and revealing*") attenuated by a luminous *white writing* ("*I have used both white pencil and white ink*").[6] Each of these material processes—writing, sanding, "whiting"—introduces a different time-frame of artistic performance and a varying force of surface tension into the process of manufacture. Sanding attenuates the surface; whiting lightens it; black Aquacryl gives it density and depth. And although each process has its own technique of application and erasure, they are all involved in a temporal cycle of repetitive layering that interleaves the bound-aries of varied forms of representation by fraying the singularity of any one surface or style.

The antihistoricist aim of the work then lies in the ceaseless movement of Houshiary's "over and over," or "erasing and revealing," which bring to light a form of *transition* embodied in both the meaning and the presence of *Fine Frenzy*: "The word 'reveal,' understood in its fullest sense, means at the same time to remove and to veil, that is, it designates a double, and contrary, movement."[7] In Houshiary's view, the transforming dimension of art is the distancing of identity and of oneself that comes from the doubleness of veiling/revealing. Whether she is addressing a hermetic word on canvas or spinning out one of her floating towers (plates 71 and 72), her works have a continual sense of expansion and contraction, as if their multiply layered surfaces were exhaling and inhaling like lung tissue, holding their breath, then repeating their hidden word or dancing their motionless dance. The illegible light aglow in Houshiary's "writing-painting"—"Calligraphy alters the lighting effects, so to speak, removing preconceptions"[8]—reminds me of the erratic moving hand visible in the works of Cy Twombly. But Houshiary's ceaseless dance of reinscribed surfaces—*Word within, word without end*—is reminis-cent of the ways in which Sufi poets may play on the word *parda*

in celebrating the whirling dance of the dervishes. *Parda* means both "veil" and "musical mode," senses that are spun together to suggest, for instance, "that the reed flute's musical modes (*parda*) have torn the veils (*parda*) that hide humanity from human eyes."[9]

The process of cultural transmission prompts us to reflect on the diasporic lives of artists who share diverse cultural affiliations and itinerant social identifications. The artworks' layered transi-tion across various mediums of manufacture echoes the artists' complex and displaced relation to territoriality—exile and belonging, habitation and homelessness. In what way does the diasporic movement back and forth across countries and cultures relate to artworks whose time-lagged materials and techniques place them somewhere between the past and the present? Fereshteh Daftari raises the cultural and political stakes when she asks of her artists, *Islamic or not?* This may sound like a question that arises from the narcissistic mirroring of the politics of identity, but it represents an issue that is central to the diasporic dialogue and has been addressed by many of our artists. Shirana Shahbazi, who was born in Tehran, moved to Germany, and now lives in Zurich, is intolerant of critics who give her work a plainly political or culturalist (national) genealogy:

> Presumably either the subject was meant to be that I'm Iranian or that I'm trying not to be. . . . I wasn't trying to define my roots or my identity or whatever because I'm very clear about it. . . . I don't have any problems living between borders and so on. Then people come with their difficulties trying to define who you are, where your work comes from . . . and they get into trouble because they can't put you in very simple terms. East vs. West is very simplistic.[10]

Iranian or not? That is not the question. A better measure of Shahbazi's "visual heritage"—both her use of it and the distance she takes from it—is to be found in her reflections on the problem of scale, volume, and presence in Iranian visual culture. Although traditional Iranian art forms—miniatures, carpets, tiles—are quite modest in scale, there is an inflated grandiloquence in their choices of subject matter: "I have found that we don't represent things that are normal—just an ordinary portrait, a mountain. . . . If a mountain is depicted there then it has to be the highest, the most beautiful, important mountain."[11] Shahbazi deploys the method of layering I've described by using the carpet as the screen for a "photographic" portrait of an unnamed woman look-ing slightly askance—a look that is confronted by its double in an exact replica printed on aluminum (plates 20 and 21). The slowly woven carpet becomes the medium for the instant snap-shot; the ordinary portrait now transforms the carpet's surface,

which traditionally bore great legends and symbols. Shahbazi's art is not about identity; it is about an aesthetics of diasporic inventory and its mediations. The transmission—and translation—of the frame and "ownership" of the image, its changing media and technology, give her work a complex, hybrid genealogy which is shared by the Palestinian-American artist Emily Jacir.

Jacir's work seems to reflect a commitment to the establishment of an independent Palestinian state, and to the rights and representations of its citizens. But when an interviewer asks her the question *Who is your community?* she refuses to answer. Her work, she insists, is about "going back and forth":

> It is about the relationship of myself and my experience and my body to my surroundings. Whether it's here or in New York or in Ramallah. It is about passing through places . . . about me wandering through space and time, and about borders and crossings, and exchanges.[12]

Jacir's response, like Shahbazi's, refuses the suggested identification *Palestinian or not.* Although committed to a national home for the Palestinians, she chooses not to subscribe to the potent communal myths of cultural authenticity that so often drive the exclusionary impulse in any nationalist movement. Jacir's account of her work interposes the space and time of the body as a bridge across "these artificial islands and borders that have been created."[13] The two-video installation *Ramallah/New York* (2004–5; plates 36 and 37) juxtaposes scenes of everyday Palestinian life shot in similar locations in Ramallah and New York; so careful is Jacir to place her figures in the same position in the frame, and to take the shot from virtually the same angle, that it is difficult to tell apart the different locations of the various mise-en-scènes. *New York or not? Ramallah or not?* It is almost impossible to answer these questions, and that is precisely the point.

Jacir's suggestion is not, I believe, that Ramallah and New York are indistinguishable from each other, nor is she drawing our attention to anything as banal as the benevolent truism that "ordinary" people lead the same sort of lives wherever they may be, only circumstances forever change their histories. Jacir's montage of fungible locations and fragile bodies takes a more oblique view of the politics of everyday life: her purpose in making it almost impossible to *visually* decipher the difference between the locations—Ramallah, New York—is to induce an anxious undecidability in the frame of representation and the act of viewing. In trying to identify these geopolitical locations against the odds, the ruse of the title is to acknowledge the specificity of site while eliding visual recognition. The viewer is split—or doubled?—in vacillating between frames, trying to respond to the ruse of the title. Which is which? Where is *here*? If read from the perspective of displacement, the work sets out to relate the two scenarios

to each other—and to the viewer, who stands uncertainly in between the screens—through a diasporic narrative of "going back and forth. . . . It is about passing through places . . . about borders and crossings, and exchanges." In these seemingly settled scenes of quotidian activity—in the complete absorption of both hairdressers with their clients' hair, for instance—there is an unmistakable sense of disorientation and displacement once we realize that whether we are in Ramallah or in New York, we are dealing with the lives of Palestinian exiles and refugees, of peoples who feel unhomed or not yet integrated into a national homeland.

Does the invisibility of difference mean that Ramallah and New York are similar historical and political realities in the diasporic imagination? Or that, at the level of everyday life, there is no difference between them? Or does going back and forth blur the asymmetries of power and place? Here, again, Jacir's emphasis on "ordinary" people and everyday scenes represents a complex artistic decision. She acknowledges the influence of On Kawara on her work, and nobody understands better than he what a difference a day makes. The date paintings that Kawara has been making for forty years—each work made within the span of the single day whose date it shows—are the most intelligent and insightful icons of the fragility and the forbearance of the diurnal cycle, the persistence of the actions and obligations of daily life in the midst of history's contingency, even tragedy. The daily calendar is also a record of survival. We do not know for certain which of Jacir's scenes takes place in Ramallah and which in New York, but what we do learn from her mondial montage is that the human measure of time is sustained by the body's daily wakefulness, its civic activities and social relations played out in specific life worlds. The clock of corporeality ticks away with a distinct rhythm and pace, back and forth, within history's louder tolling of the times of peoples and the trauma of countries. Jacir's focus on locality in Ramallah and New York does not neglect more global issues; there is a foreboding that at any moment on any day—no more than a minute after the videocam has recorded a person's life and its singular sediments—there could be a catastrophe that would forever maim the routine of civil society and the culture of community. In one of these places—we don't know which—there lurks the epochal memory of 9/11; in the other, there is the everyday fear of violence and violation. Our inability to distinguish between locations commits us to going back and forth, across both historical and political terrains. Through this diasporic movement we commit ourselves to a double duty: to affiliate with the global ethic of choosing to become involved with the historic fate of both societies, Ramallah/New York.

Islamic or not? Western or not? Modernist or not? Feminist or not? Political or not? Personal or not? The artists in this show

refuse such polarizing identifications, and reject univocal choices that define social and personal freedoms negatively. Just as they set their own terms of aesthetic representation (combining traditional forms and contemporary art), so do they insist on creating their own frames of political recognition. Their resistance to being tied to myths of national identity or cultural authenticity does not come from a doctrinal espousal of global nomadism or transnationalism. If the contemporary work that they make reaches out, in part, to antique cultural forms and traditional modes—of calligraphy, weaving, highly crafted picture-making— it should not be read as a form of national or cultural atavism. Such appeals to the "past," in the service of avant-garde art practices, are attempts at historical and aesthetic revisionism; they are ways of creating new cultural genealogies for nation-states—Pakistan or Iran, for instance—that have fallen prey to religious fundamentalisms, military rule, and significant breaches of rights and representations in the public sphere.

What, however, does it mean to reshape a national symbol even before the nation has been achieved? How does an artwork transform the very terms of freedom when the future is an open question? Mona Hatoum's iconic *Keffieh* (1993–99; plate 25) intervenes in the symbolic representation of the Palestinian struggle by resorting to the ancient art of embroidery in order to "democratize" the insignia of emancipation. The keffieh—the cotton headscarf worn by Middle Eastern men—has developed a macho aura in the Palestinian culture of political resistance. Hatoum embroiders its pattern with women's hair, leaving some tresses uncut, flowing off the square frame of the cloth in a way that breaks the symmetry of the symbol and contests the fiber of male resistance. Feminizing the keffieh, Hatoum writes, "brings out a number of interesting and contradictory issues. Can you, for instance, imagine a man wearing it with trailing female hair? It also brings the female voice into the protest."[14] How does that female voice reshape the social fabric of protest? Hatoum suggests various readings: the scarf becomes uncanny, in the Freudian sense of the word "*unheimlich*"; and the sprouting hair suggests female vitality, unrestrained sexuality, the breaking of restraining barriers. One could suggest that the living female hair woven into this garment, so widely worn in regions where many women veil their heads outdoors, extends the public domain to include the rights of women and thus introduces the representation of "difference" as something other than a homogenizing principle of universal equality.

What intrigues me, however, is another aspect of the introduction of female hair into the male symbol of the keffieh. Functioning at once as both a found object and a deliberately placed sign, this fragment of the woman's body turns the keffieh into an erotic, fetishized object that embodies both political and psychic power. The hair does not merely feminize the macho symbol, operating

as a secondary form of figurative layering. A metonym of the woman's body intimately embroidered into the fabric of the cloth, it makes public the fact that the masculine image of political struggle often aims its aggression in two directions: external and internal. The macho style is an externalized response to the powers of oppression and domination; but it is also a form of domination turned inward, within the community, poised against the presence and participation of women, whose voices are repressed or sublimated in the cause of the struggle. Hatoum's feminized headscarf reveals this disavowal of the place of women and reinserts their point of view through the embroidered strands of hair that hang loose beyond the boundary, breaking the pictorial grid of the material in the process of redefining the symbolic surface of political struggle.

It must not be imagined that the art of resistance or revision is doctrinaire and dour, devoid of the strange joy of making. The feminization of the keffieh has its own subversive humor: "Can you, for instance, imagine a man wearing it with trailing female hair?" asks Hatoum. The "trailing hair" is also reminiscent of the spectral female form that spreads like a dark stain along the length of Sikander's *Perilous Order* (1997; plate 9). In this instance a woman's shadow falls across the centered inner frame of the miniature, partly obscuring the portrait of the Mughal prince, whose presence now develops an ambiguous layered profile and appears uncannily feminized. In an echo of the hair that breaks the boundary of the keffieh, Sikander's spectral female free-form blurs the spatial geometry and disrupts the decorative design that frames the miniature. This darker shadow makes visible the translucent tension that floats on the layered surface: the conversation between the thematic revision of the Mughal form and the Polke-dot repetitions of late modernism.

The art of global diaspora is often, hopefully, described as the art of the future—a projected future of multicultural societies, well-traversed territories, and translated traditions. *Without Boundary* interleaves tradition and innovation, technique and translation, to suggest that diasporic art may take us back to the future—a journey of precarious and productive tensions. The past, it suggests, is another country or culture (but one that is also your own), and finds its space between the lines, and its time across the frames, of the present. These artists make us think again of the role played by techniques of layering and unveiling in the *longue durée* of cultural transmission.

The past reaches out to you, yearning to be reborn. Will you embrace it compliantly for what it was, once and always: "influence," "tradition," "convention," "custom"? Or will you struggle passionately with the past, as you do with a lost lover or a half-remembered memory, knowing that things can never be the same again . . . not today. Not ever.

Notes In memory of Sorab Bhabha, 1953–2005

1. On global disjuncture, see David Held, Anthony McGrew, David Goldblatt, and Jonathan Perraton, *Global Transformations: Politics, Economics and Culture* (Stanford: at the University Press, 1999), especially pp. 449–50.

2. Shahzia Sikander, "Nemesis: A Dialogue with Shahzia Sikander by Ian Berry," in Berry and Jessica Hough, *Nemesis* (Saratoga Springs: The Tang Teaching Museum and Art Gallery, and Ridgefield, Conn.: The Aldrich Contemporary Art Museum, 2005), p. 14.

3. Glenn Lowry, "Manohar," in Milo Cleveland Beach, ed., *The Grand Mogul: Imperial Painting in India, 1600–1660* (Williamstown, Mass.: Sterling and Francine Clark Art Institute, 1978), p. 131.

4. John Ash, "Y.Z. Kami," *Artforum* 34, no. 7 (March 1996): 95.

5. Shirazeh Houshiary, quoted in Stella Santacatterina, "Conversation with Shirazeh Houshiary," *Third Text* 27 (Summer 1994): 84.

6. Houshiary, email to Fereshteh Daftari, November 2005.

7. Santacatterina, in "Conversation with Shirazeh Houshiary," p. 78.

8. Abdelkebir Khatibi and Mohammed Sijelmassi, *Splendour of Islamic Calligraphy* (London: Thames & Hudson, 1995), p. 91.

9. Annemarie Schimmel, *Rumi's World: The Life and Work of the Great Sufi Poet* (Boston and London: Shambhalla, 2001), p. 199.

10. Shirana Shahbazi, quoted in Michele Robecchi, "You are Here," *Flash Art* 36, no. 233 (November–December 2003): 78.

11. Ibid., p. 77.

12. Emily Jacir, in Stella Rollig, "Stella Rollig— Emily Jacir: Interview," in Jacir, Edward Said, Martin Sturm, et al., *Emily Jacir: Belongings* (Vienna: O.K. Center for Contemporary Art, 2004), pp. 8–9.

13. Ibid., p. 9.

14. Mona Hatoum, in *Mona Hatoum: Images from Elsewhere. Week 36*, exh. brochure (London: fig-1, 2000), n.p.

1. **SHIRAZEH HOUSHIARY**. *Fine Frenzy*. 2004. Black and white Aquacryl, white pencil, and ink on canvas, 6' 2³/₁₆" x 6' 2³/₁₆" (190 x 190 cm). Private collection

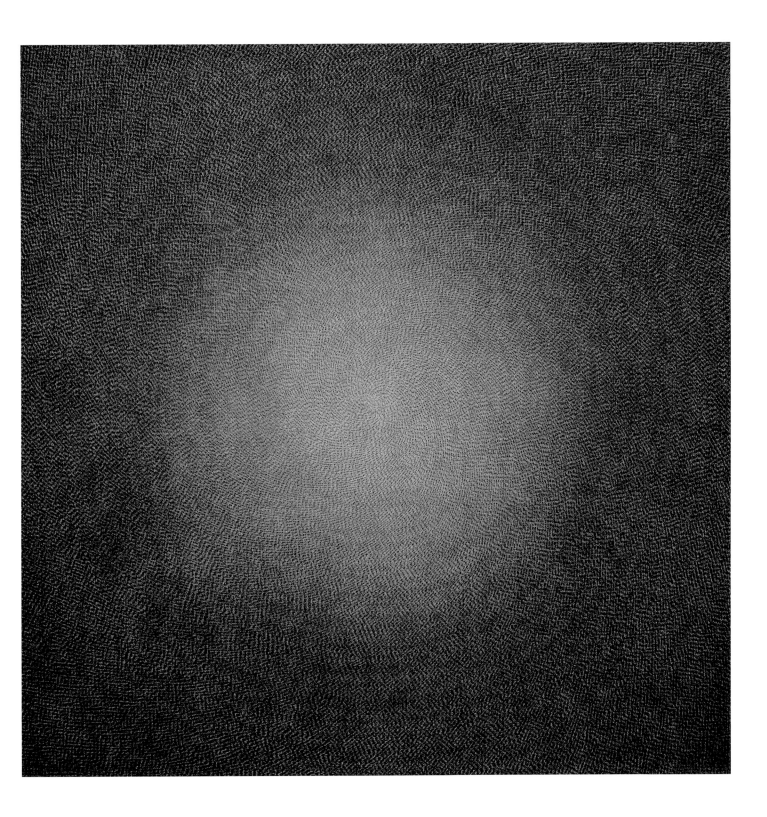

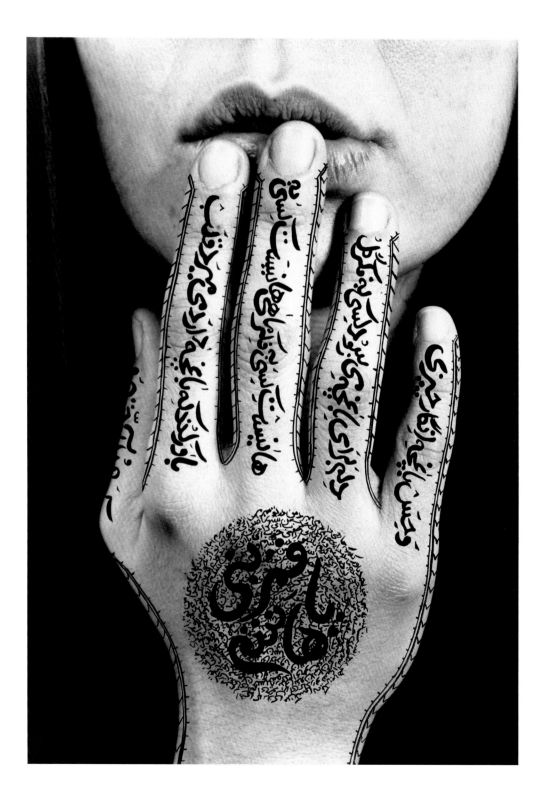

2. **SHIRIN NESHAT**. *Untitled*. 1996. RC print and ink, 47⁷/₈ x 33³/₄" (121.6 x 85.7 cm). Courtesy the artist and Gladstone Gallery, New York

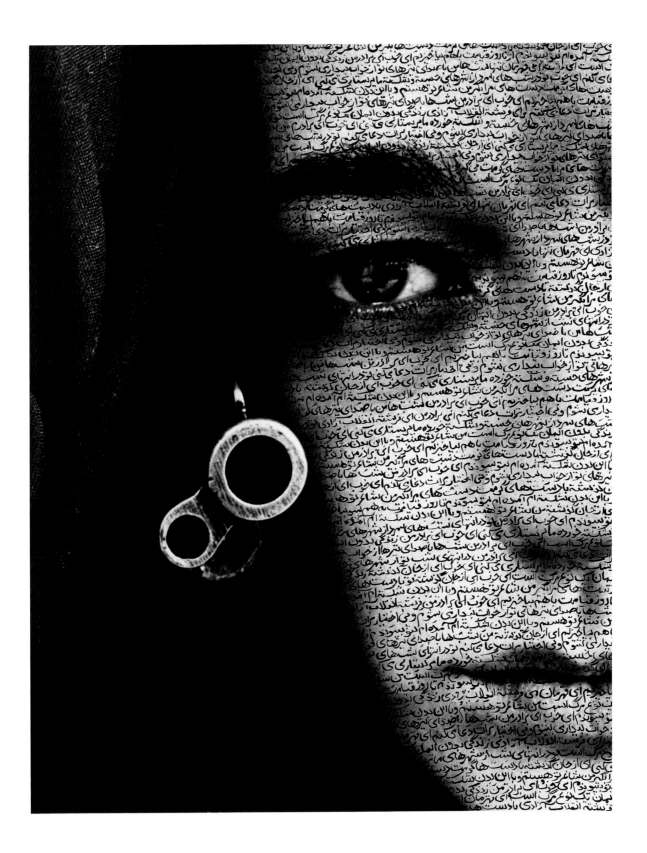

3. **SHIRIN NESHAT**. *Speechless*. 1996. RC print and ink, 46 3/4 x 33 7/8" (118.7 x 86 cm). Courtesy the artist and Gladstone Gallery, New York

4. **KUTLUG ATAMAN**. *World (no. 1)*. 2003. Video installation: DVD, DVD player, LCD flat-panel wall-mounted monitor, 17 x 19" (43 x 48 cm).
Courtesy the artist and Lehmann Maupin Gallery, New York

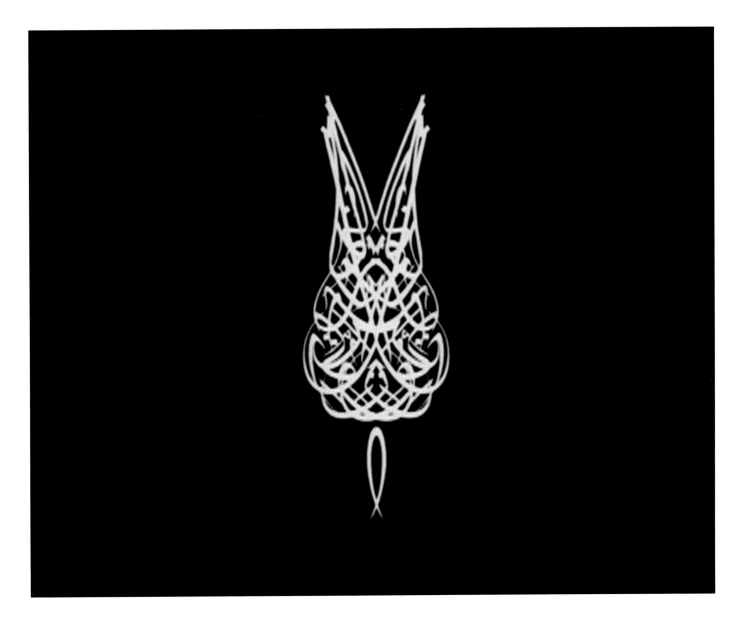

5. **KUTLUG ATAMAN**. *Beautiful (no. 2)*. 2003. Video installation: DVD, DVD player, LCD flat-panel wall-mounted monitor, 17 x 19" (43 x 48 cm).
Courtesy the artist and Lehmann Maupin Gallery, New York

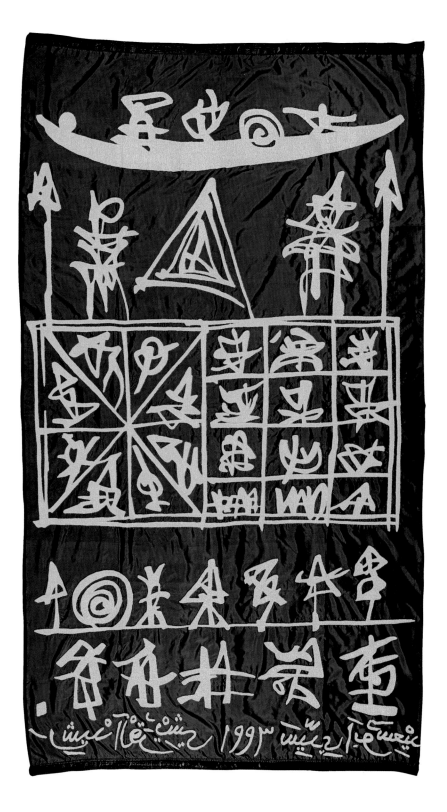

6. **RACHID KORAÏCHI**. *Salome*. 1993. Gold and indigo handwoven silk, 10' 2 ⁷/₁₆" x 6' 2" (311 x 188 cm). Collection the artist

7. **GHADA AMER**. *The Definition of Love according to Le Petit Robert*. 1993. Embroidery and gel on canvas, 39 3/8 x 39 3/8" (100 x 100 cm).
Collection FRAC Auvergne, France

8. **SHAHZIA SIKANDER**. *Dissonance to Detour*. 2005. Animation, DVD, 3 minutes, 28 seconds. Courtesy the artist and Sikkema Jenkins and Co., New York

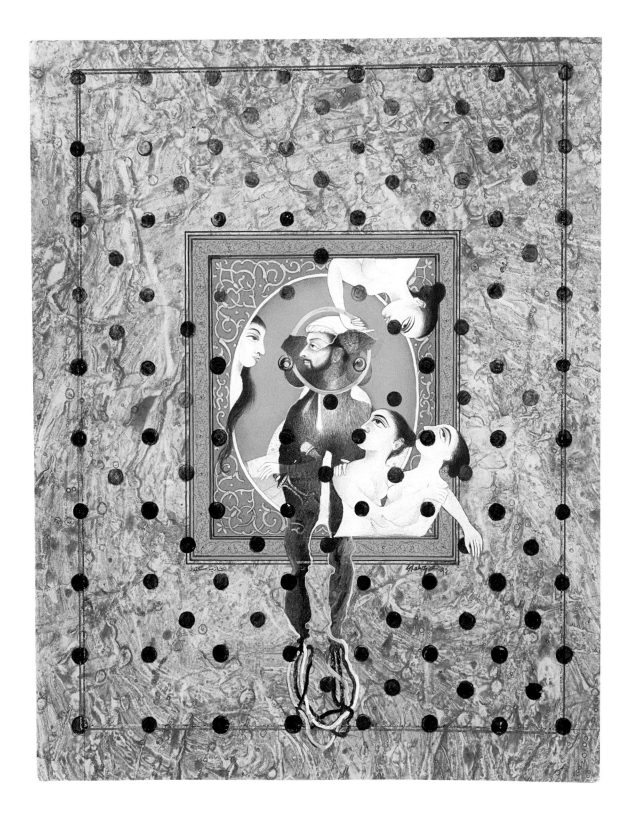

9. **SHAHZIA SIKANDER**. *Perilous Order*. 1997. Vegetable pigment, dry pigment, watercolor, and tea water on paper, $10^{3}/_{8}$ x $8^{3}/_{16}$" (26.4 x 20.8 cm).
Whitney Museum of American Art, New York. Purchase, with funds from the Drawing Committee, 1997

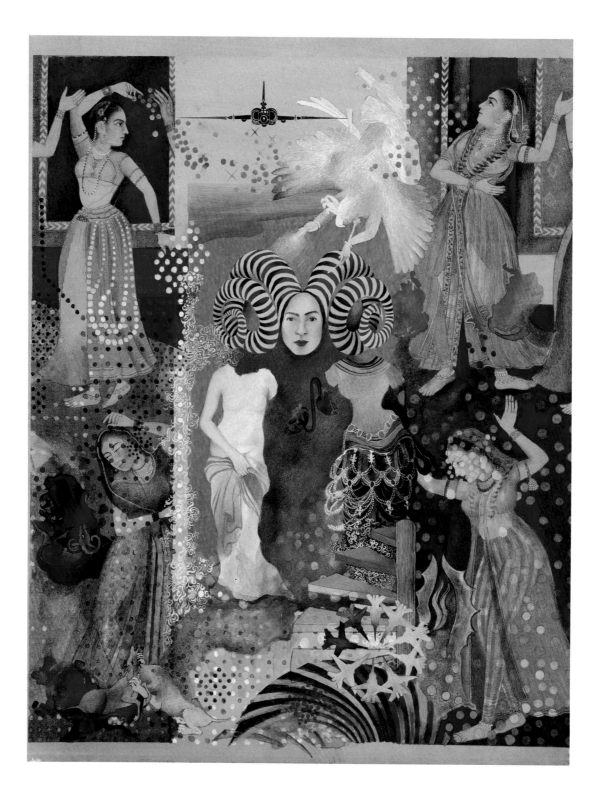

10. SHAHZIA SIKANDER. *Pleasure Pillars*. 2001. Watercolor, dry pigment, vegetable color, tea, and ink on wasli paper, 12 x 10" (30.5 x 25.4 cm).
Collection Amita and Purnendu Chatterjee

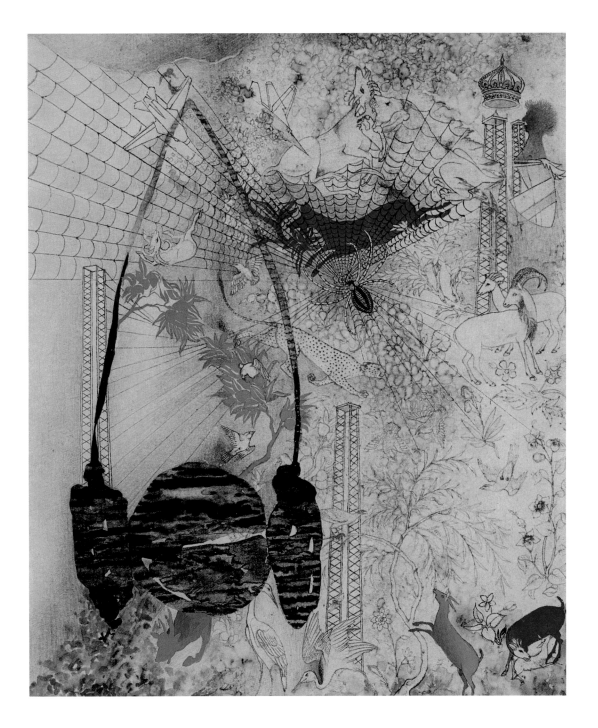

11. **SHAHZIA SIKANDER**. *Web*. 2002. Watercolor, tea, and ink on wasli paper, 8 $^{15}/_{16}$ x 7 $^{7}/_{16}$" (22.7 x 18.9 cm) . Museum of Art, Rhode Island School of Design, Providence. Paula and Leonard Granoff Fund

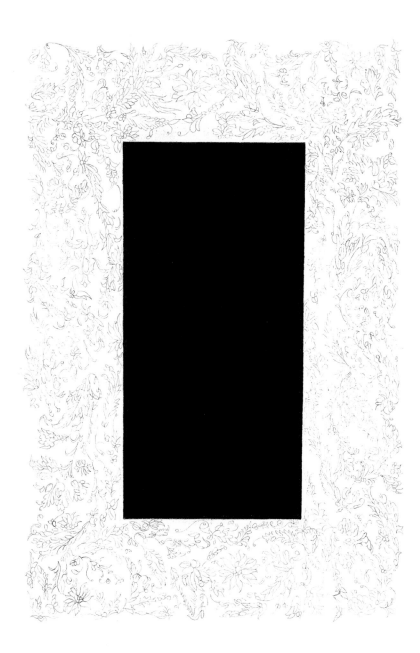

12. **SHAHZIA SIKANDER**. *#2* from the series 51 Ways of Looking. 2004. Graphite on paper, 12 x 9" (30.5 x 22.9 cm).
Collection Rachel and Jean-Pierre Lehmann

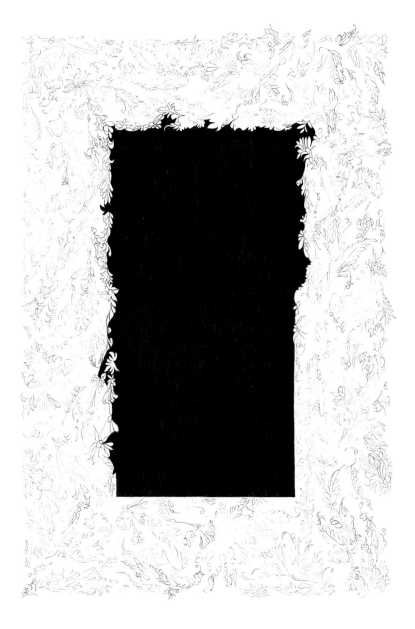

13. **SHAHZIA SIKANDER**. *#3* from the series 51 Ways of Looking. 2004. Graphite on paper, 12 x 9" (30.5 x 22.9 cm).
Collection Rachel and Jean-Pierre Lehmann

14. **SHAHZIA SIKANDER**. *#12* from the series 51 Ways of Looking. 2004. Graphite on paper, 12 x 9" (30.5 x 22.9 cm). Gandar Collection

15. **SHAHZIA SIKANDER**. *#24* from the series 51 Ways of Looking. 2004. Graphite on paper, 12 x 9" (30.5 x 22.9 cm).
Collection Lori Spector and Max Lang

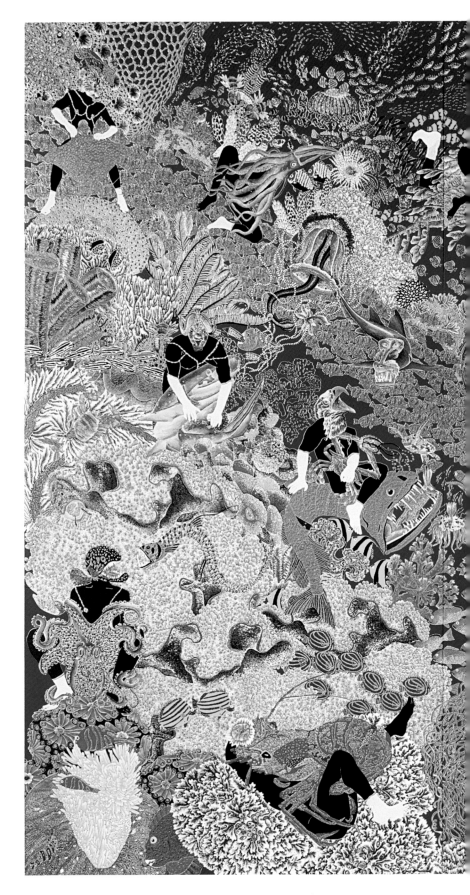

16. **RAQIB SHAW**. *The Garden of Earthly Delights III*. 2003. Mixed media on board, three panels, overall: 10 x 15' (305 x 457.5 cm), each panel: 10 x 5' (305 x 152.5 cm). Private collection, courtesy Victoria Miro Gallery, London

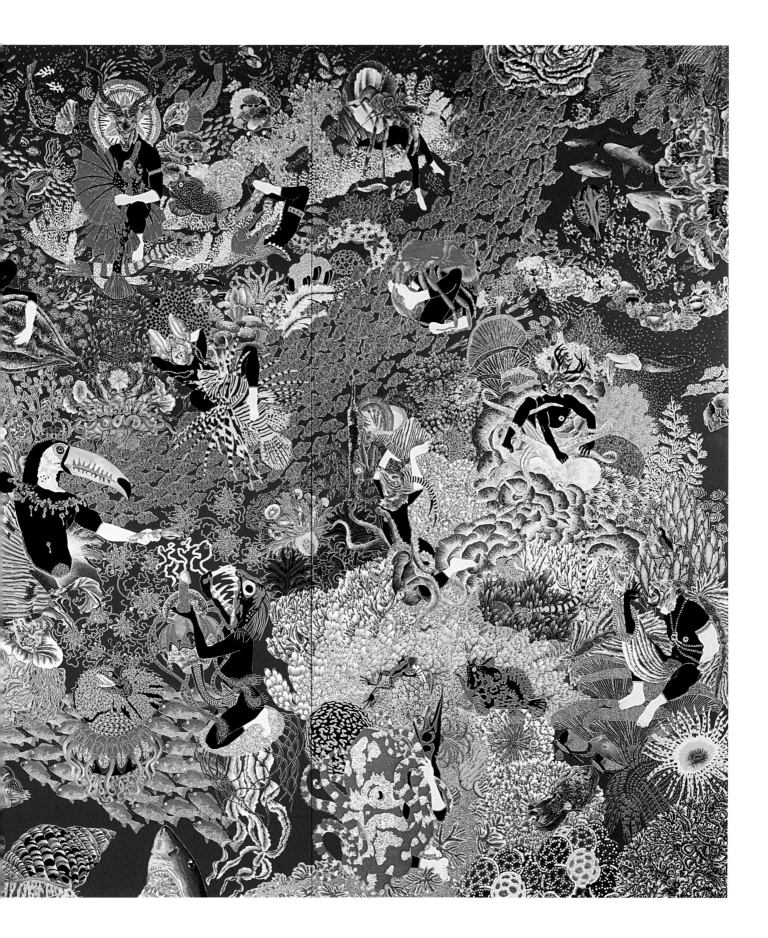

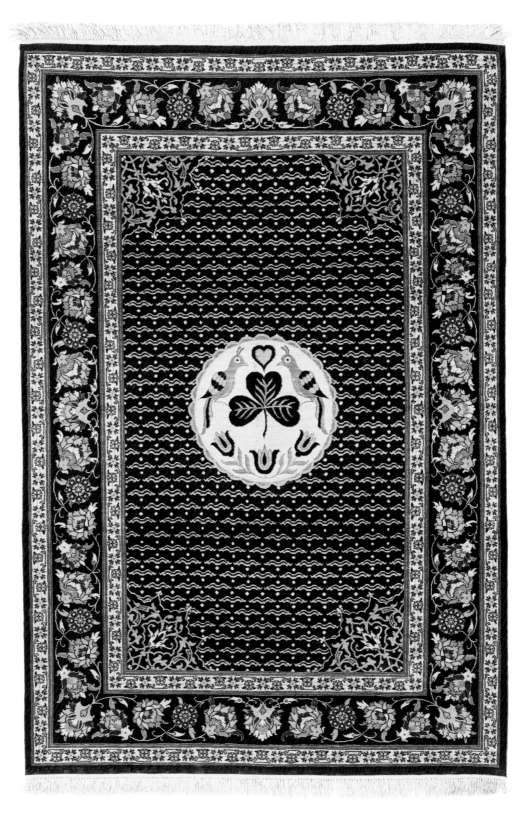

17. **MIKE KELLEY**. *Untitled*. 1996–97. Hand-woven silk (made in Ghom, Iran), 40 x 60" (101.6 x 152.4 cm). Courtesy Brian Butler, Los Angeles

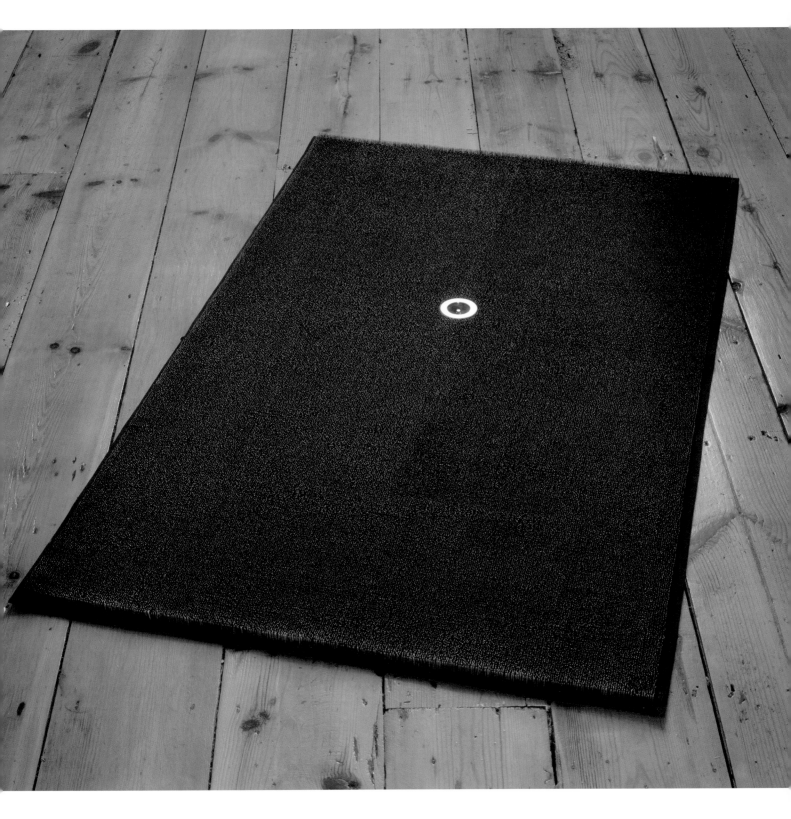

18. **MONA HATOUM**. *Prayer Mat*. 1995. Brass pins, brass compass, canvas, and glue, 5 7/8 x 26 3/8 x 44 1/8" (15 x 67 x 112 cm). British Council, London

19. **SHIRANA SHAHBAZI**. *[Woman-02-2003]*. 2003. C-print on aluminum, 59 $^1/_{16}$ x 47 $^1/_4$" (150 x 120 cm). Courtesy Gallery Bob van Orsouw, Zurich, and Salon 94, New York

20. **SHIRANA SHAHBAZI**. *[Farsh-01-2004]*. 2004. Hand-knotted wool and silk carpet, 27 9/16 x 19 11/16" (70 x 50 cm). Courtesy Gallery
Bob van Orsouw, Zurich

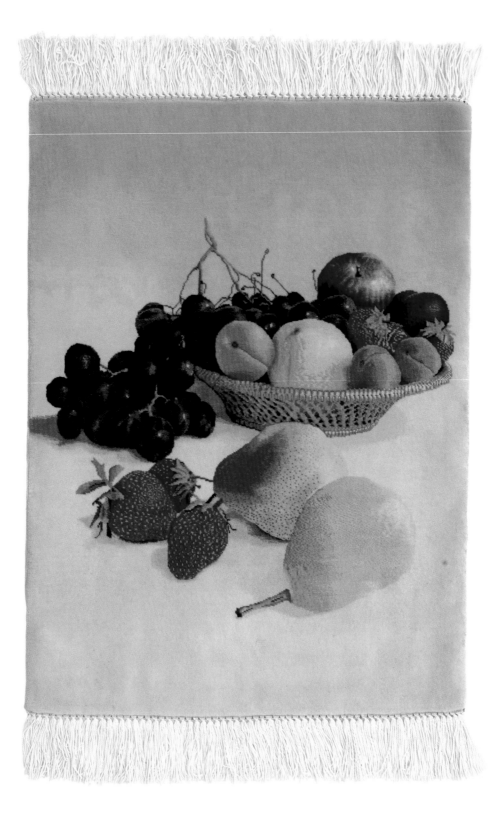

21. **SHIRANA SHAHBAZI**. *[Farsh-08-2004]*. 2004. Hand-knotted wool and silk carpet, 27^9/$_{16}$ x 19^{11}/$_{16}$" (70 x 50 cm). Courtesy Gallery Bob van Orsouw, Zurich

22. **SHIRANA SHAHBAZI**. *[Farsh-11-2005]*. 2005. Hand-knotted wool and silk carpet, 23 $^5/_8$ x 27 $^9/_{16}$" (60 x 70 cm). Courtesy Gallery Bob van Orsouw, Zurich

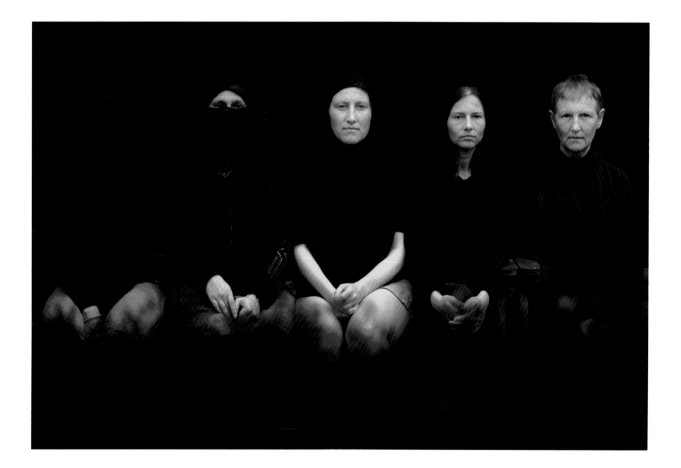

23 and 24. **JANANNE AL-ANI**. *Untitled I and II*. 1996. Two gelatin silver prints, each 47¹/₄" x 70⁷/₈" (120 x 180 cm). Courtesy the artist and Union, London

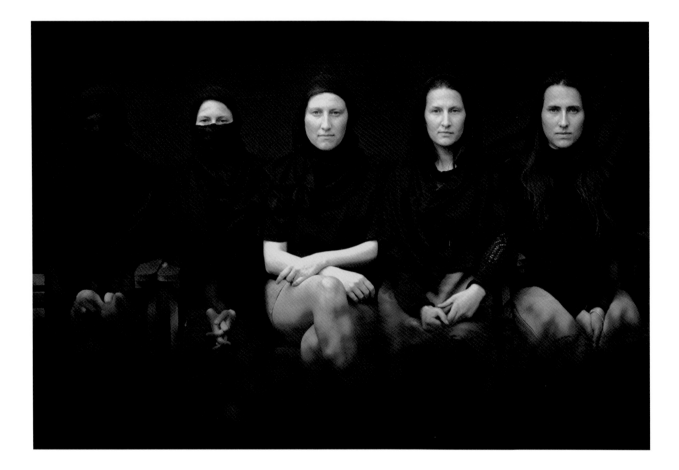

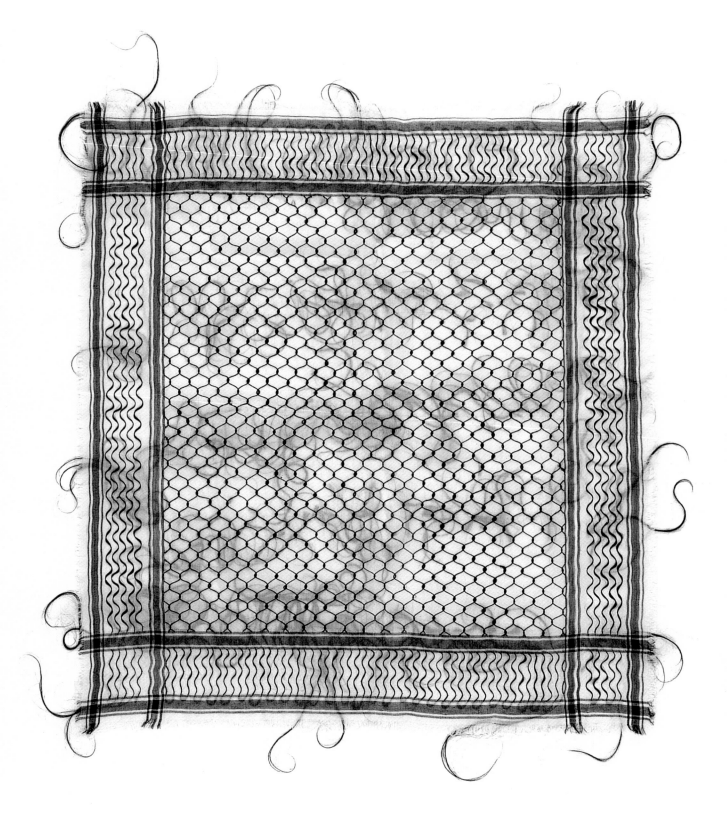

25. **MONA HATOUM**. *Keffieh*. 1993–99. Human hair on cotton, 45 1/4 x 45 1/4" (114.9 x 114.9 cm). Collection Peter Norton, Santa Monica

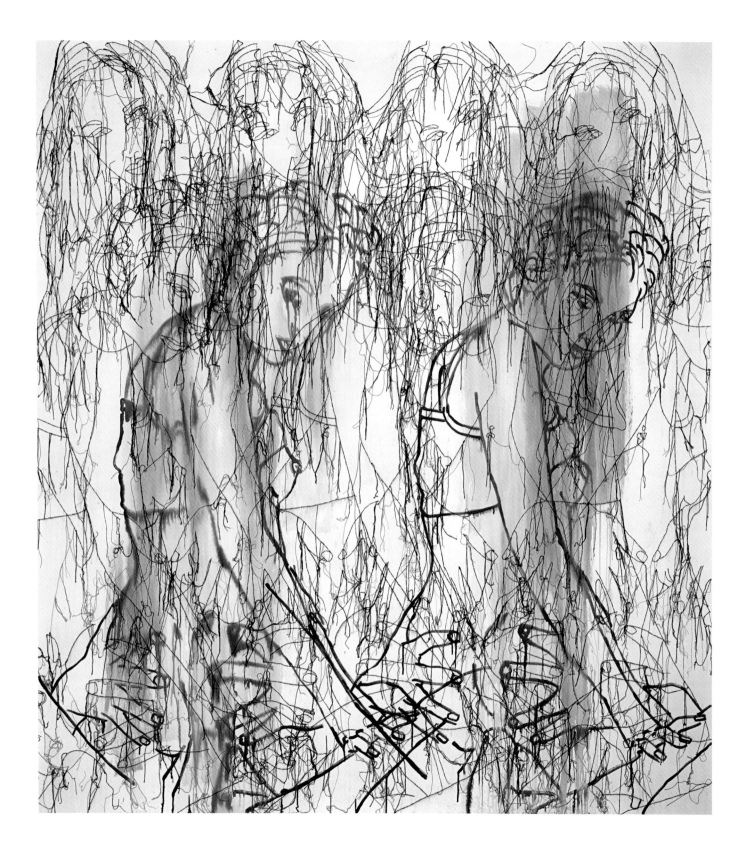

26. **GHADA AMER**. *Eight Women in Black and White*. 2004. Acrylic, embroidery, and gel medium on canvas, 7' x 6' 4" (213.4 x 193 cm).
Courtesy the artist and Gagosian Gallery, New York

27. **MARJANE SATRAPI**. *Persepolis* ("Kim Wilde" chapter). 2001. Ink on paper, nine drawings, each 16 5/16 x 11 11/16" (42 x 29.7 cm). Courtesy the artist

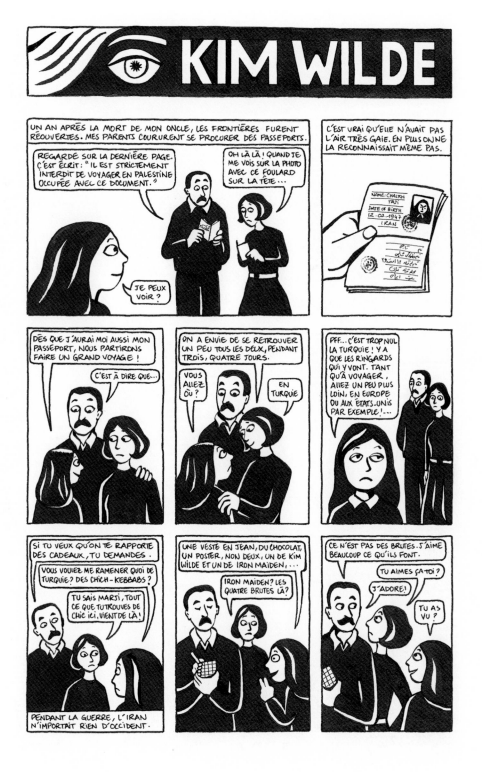

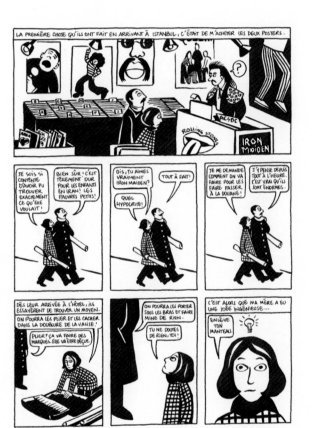

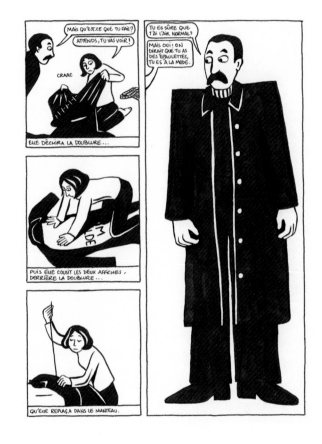

28–31. MARJANE SATRAPI. *Persepolis* ("Kim Wilde" chapter). 2001. Ink on paper, nine drawings, each 16 9/16 x 11 11/16" (42 x 29.7 cm). Courtesy the artist

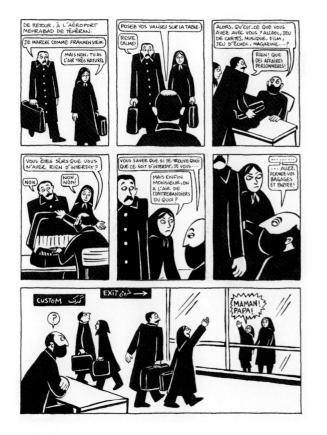

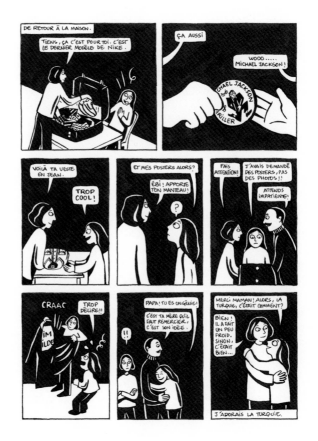

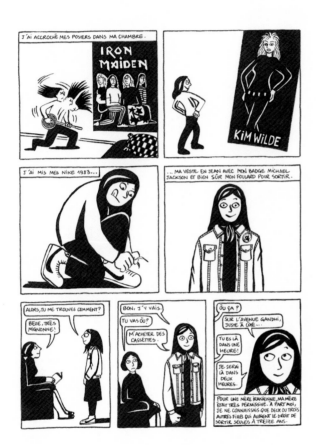

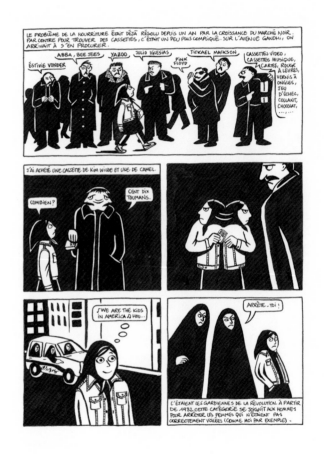

32–35. MARJANE SATRAPI. *Persepolis* ("Kim Wilde" chapter). 2001. Ink on paper, nine drawings, each 16 9/16 x 11 11/16" (42 x 29.7 cm). Courtesy the artist

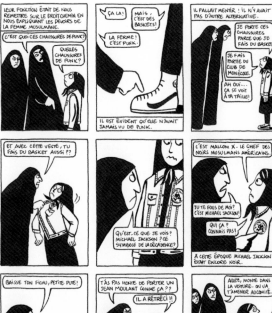
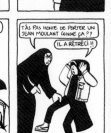

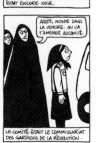
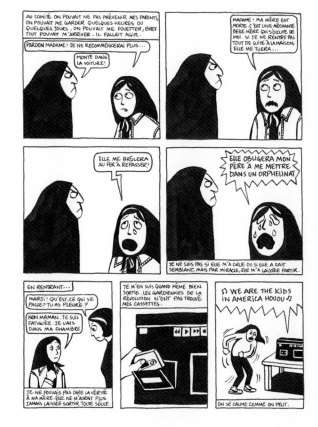

36 and 37. **EMILY JACIR**. *Ramallah/New York*. 2004–5. Two-channel video installation on DVD, dimensions variable. 38 minutes. Courtesy the artist and
Alexander and Bonin, New York

38. **SHIRIN NESHAT**. *The Last Word*. 2003. Gelatin silver print, 37" x 7' 11" (94 x 241.3 cm). Courtesy the artist and Gladstone Gallery, New York

Civilizationally, We Do Not Dig Holes to Bury Ourselves[3]
Documents from the Fakhouri File[1] in The Atlas Group Archive[2]

THE ATLAS GROUP / WALID RAAD

1. The Fakhouri file includes notebooks, films, videotapes, and photographs. The documents in this file are attributed to Dr. Fadl Fakhouri. Dr. Fakhouri represents a renowned Lebanese historian who bequeathed documents to The Atlas Group upon his death in 1993.

2. The Atlas Group was a project (1977–2004) and a foundation that researched and documented the contemporary history of Lebanon. The Atlas Group found, produced, preserved, and studied documents that shed light on this history. The documents are preserved in The Atlas Group Archive in New York and Beirut.

3. The only photographs of Dr. Fakhouri consist of a series of self-portraits he produced during his one and only trip outside of Lebanon, to Paris and Rome in 1958 and 1959.

39–42. **THE ATLAS GROUP / WALID RAAD**. *Civilizationally, We Do Not Dig Holes to Bury Ourselves*. 2003. Twenty-four framed archival ink-jet prints with accompanying wall text, each (framed): 10³/₁₆ x 12³/₈" (25.8 x 31.5 cm); wall text: 39³/₈ x 25⁵/₈" (100 x 60 cm). Courtesy The Atlas Group and Sfeir-Semler Gallery, Hamburg-Beirut

Rome 1959

Paris 1958

Rome 1959

Paris 1959

Paris 1958

Paris 1958

Paris 1958

Paris 1958

43–50. THE ATLAS GROUP / WALID RAAD. *Civilizationally, We Do Not Dig Holes to Bury Ourselves*. 2003. Twenty-four framed archival ink-jet prints with accompanying wall text, each (framed): 10³/₁₆ x 12³/₈" (25.8 x 31.5 cm); wall text: 39³/₈ x 25⁵/₈" (100 x 60 cm). Courtesy The Atlas Group and Sfeir-Semler Gallery, Hamburg-Beirut

Rome 1959

Rome 1959

Paris 1958

Paris 1958

Paris 1958

Rome 1959

Rome 1959

Rome 1959

51–58. **THE ATLAS GROUP / WALID RAAD**. *Civilizationally, We Do Not Dig Holes to Bury Ourselves*. 2003. Twenty-four framed archival ink-jet prints with accompanying wall text, each (framed): 10³/₁₆ x 12³/₈" (25.8 x 31.5 cm); wall text: 39³/₈ x 25⁵/₈" (100 x 60 cm). Courtesy The Atlas Group and Sfeir-Semler Gallery, Hamburg-Beirut

Rome 1959

Paris 1958

Paris 1958

Paris 1958

Paris 1958

Paris 1958

59–62. THE ATLAS GROUP / WALID RAAD. *Civilizationally, We Do Not Dig Holes to Bury Ourselves*. 2003. Twenty-four framed archival ink-jet prints with accompanying wall text, each (framed): 10³/₁₆ x 12³/₈" (25.8 x 31.5 cm); wall text: 39³/₈ x 25⁵/₈" (100 x 60 cm). Courtesy The Atlas Group and Sfeir-Semler Gallery, Hamburg-Beirut

Paris 1958

Paris 1958

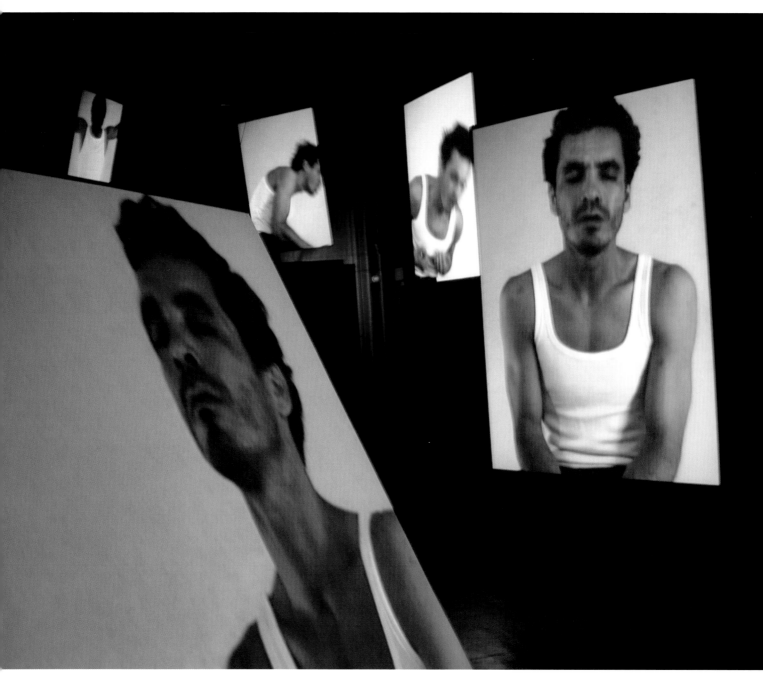

63 and 64. **KUTLUG ATAMAN**. *99 Names*. 2002. Five-screen video installation: five DVDs, five DVD players, five LCD projectors, five speakers, five reflective screens, dimensions variable. Courtesy the artist and Lehmann Maupin Gallery, New York

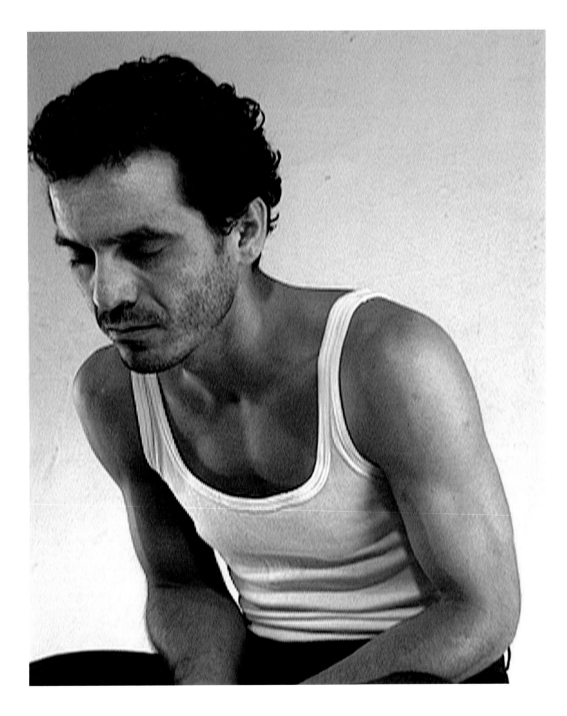

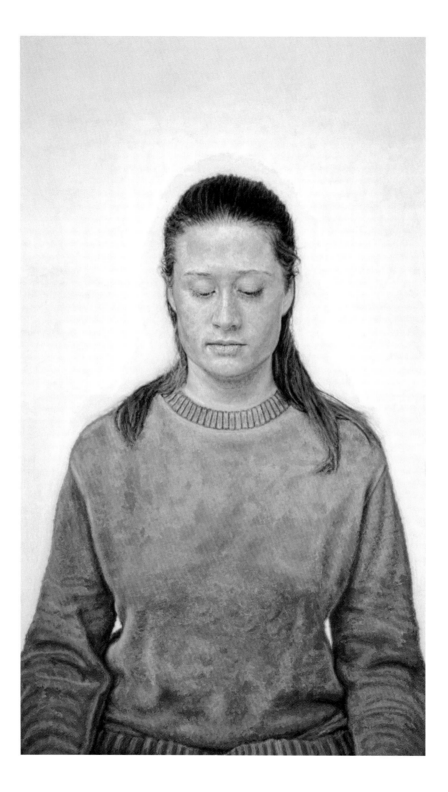

65. **Y.Z. KAMI**. *Untitled*. 2004–5. Oil on linen, 11' 2" x 6' 6" (340.4 x 198.1 cm). Courtesy the artist and Gagosian Gallery, New York

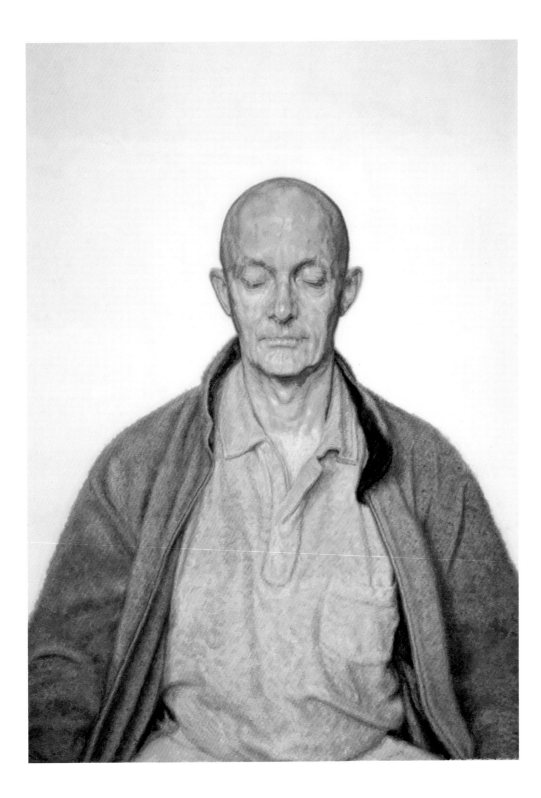

66. **Y.Z. KAMI**. *Untitled*. 2004–5. Oil on linen, 10' 8" x 7' 8" (325.1 x 233.7 cm). Collection Alberto and Katharin Spallanzani, Paris

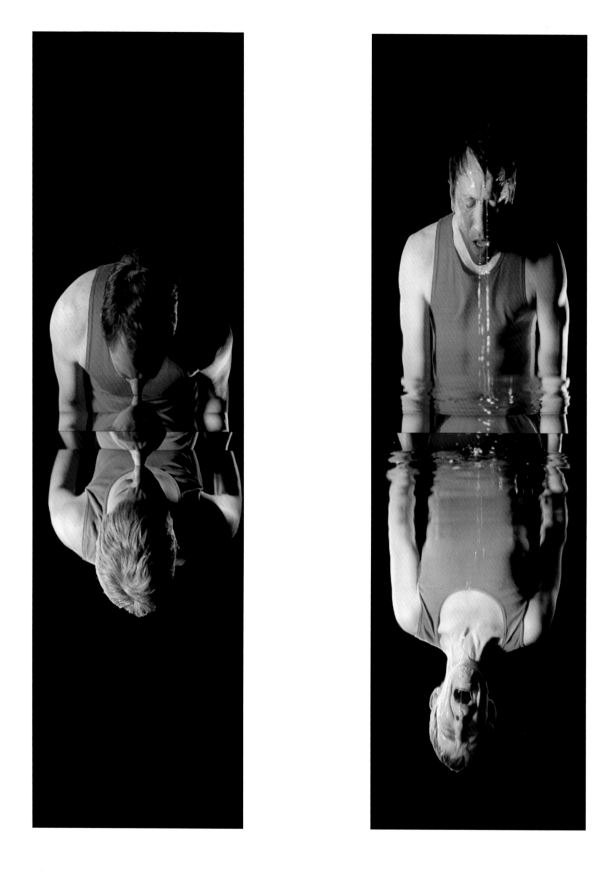

67–70. **BILL VIOLA**. *Surrender*. 2001. Color video diptych on two plasma displays mounted vertically on wall, overall: 6' 8³/₈" x 24" x 3¹/₂"
(204.2 x 61 x 8.9 cm). Private collection, New York

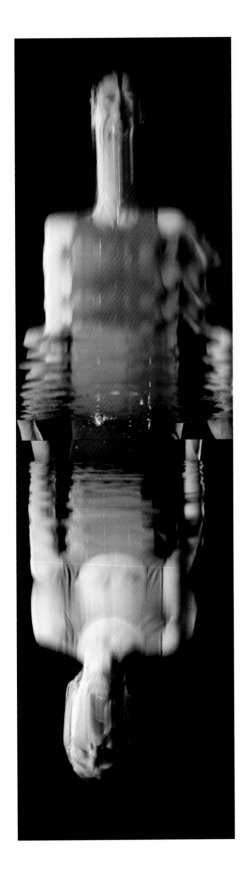
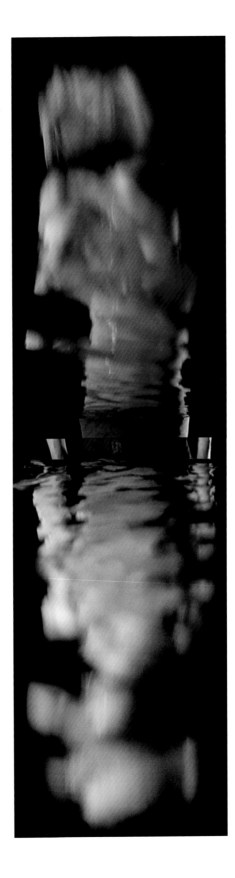

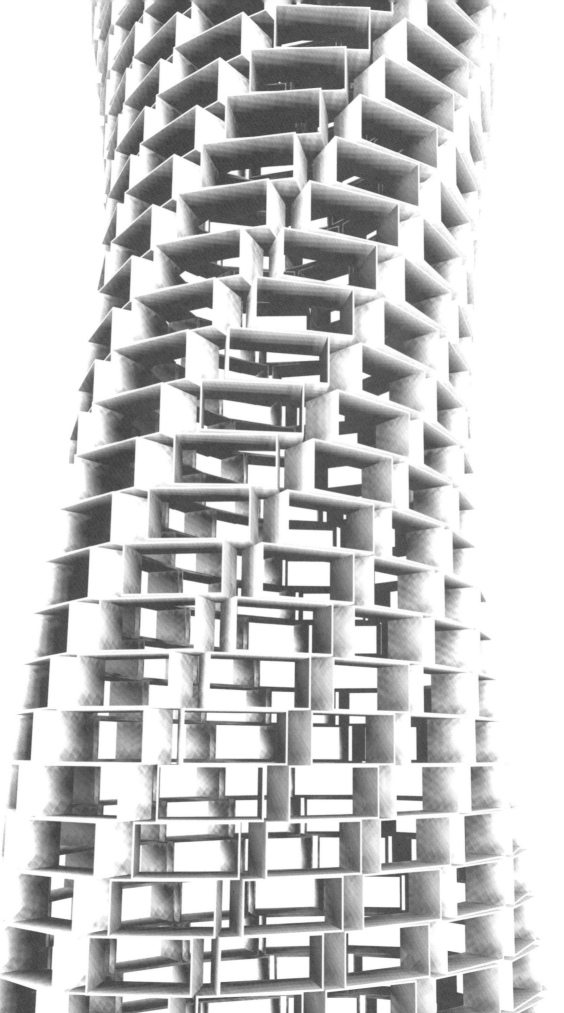

71 and 72. **SHIRAZEH HOUSHIARY** and **PIP HORNE**. *White Shadow*. 2005. Anodized aluminum, 13' 1" x 5' 7" (398.8 x170.2 cm).
Courtesy Lisson Gallery, London, and Lehmann Maupin Gallery, New York

Artists' Biographies

Exhibition histories, collection information, and bibliographies are selected rather than inclusive. All of the artists represented in the exhibition were invited to add a statement to their biography; not all of them chose to do so.

JANANNE AL-ANI

Born 1966 in Kirkuk, Iraq. Lives and works in London

Education
1997 Royal College of Art, London
1989 Byam Shaw School of Art, London

Solo Exhibitions
2004 *The Visit.* Norwich Gallery, Norwich, England; Tate Britain, London
2002 Dryphoto arte contemporanea, Prato
Musée Réattu, Arles
1999 Imperial War Museum, London
Smithsonian Institution, Washington, D.C.
1998 Margaret Harvey Gallery, University of Hertfordshire Galleries, St. Albans, England
1997 Harriet Green Gallery, London

Group Exhibitions
2005 *(Hi)story.* Kunstmuseum Thun
Identità e Nomadismo. Palazzo delle Papesse, Centro Arte Contemporanea, Siena
Regards des photographes arabes contemporains. Institut du Monde Arabe, Paris

The World Is a Stage: Stories behind Pictures. Mori Art Museum, Tokyo
2004 *Beyond East and West: Seven Transnational Artists.* Krannert Art Museum, University of Illinois, Champaign. Traveled: Louisiana State University Museum of Art, Baton Rouge; Hood Museum of Art, Dartmouth College, Hanover, N.H.; Williams College Museum of Art, Williamstown, Mass.
Women by Women. Fotografie Forum international, Frankfurt am Main
2003 *And the One Doesn't Stir without the Other.* Ormeau Baths Gallery, Belfast
DisORIENTation. Haus der Kulturen der Welt, Berlin
Harem Fantasies and the New Scheherazades. Centre de Cultura Contemporània de Barcelona. Traveled: Muséum d'Histoire Naturelle, Lyons
Veil (co-curator). The New Art Gallery, Walsall, England. Traveled: Bluecoat Arts Centre and Open Eye Gallery, Liverpool; Modern Art Oxford; Kulturhuset, Stockholm
2002 *Sans commune mesure. Image et texte dans l'art actuel.* Musée d'art moderne Lille Métropole, Villeneuve d'Ascq
2001 *Fair Play* (curator). Danielle Arnaud Contemporary Art, London. Traveled: Angel Row Gallery, Nottingham; Fondation d'Art Contemporain Daniel & Florence Guerlain, Les Mesnuls
2000 *Attitude: A History of Posing.* Victoria and Albert Museum, London
Ekbatana? Nikolaj Contemporary Art Centre, Copenhagen
In Memoriam. The New Art Gallery, Walsall, England
1996 *Contemporary Art from the Collection.* Imperial War Museum, London
John Kobal Photographic Portrait Award. National Portrait Gallery, London. Traveled: The Royal Photographic Society,

Bath; Scottish National Portrait Gallery, Edinburgh; Midlands
Arts Centre, Birmingham
1994 *Who's Looking at the Family?* Barbican Art Gallery, London

Public Collections
Ferens Art Gallery, Hull, England
Arts Council England, London
Imperial War Museum, London
Victoria and Albert Museum, London
Musée national d'art moderne, Centre national d'art et de culture
 Georges Pompidou, Paris
Smithsonian Institution, Washington, D.C.

Bibliography
Al-Ani, Jananne. "Acting Out." In David A. Bailey and Gilane
 Tawadros, eds. *Veil: Veiling, Representation and Contemporary
 Art.* Exh. cat. London: inIVA, 2003, pp. 90–107
———. "Scenes and Types." In Mona Abu Rayyan and Christine
 Tohme, eds. *Home Works: A Forum on Cultural Practices in the
 Region.* Beirut: Ashkal Alwan, The Lebanese Association for
 Plastic Arts, 2003, pp. 14–21
———. "Veil: Perception/Reception." In Bridget Crone, ed.
 The Showroom Annual 2003/4. London: The Showroom, 2004,
 pp. 46–49
Doherty, Claire, Angela Weight, and Richard Hylton. *Jananne
 Al-Ani.* London: Film and Video Umbrella, 2005
O'Brian, David, and David Prochaska. *Beyond East and West:
 Seven Transnational Artists.* Exh. cat. Champaign: Krannert
 Art Museum, 2004
Persekian, Jack, et al. *DisORIENTation: Contemporary Arab
 Artists from the Middle East.* Exh. cat. Berlin: Haus der Kulturen
 der Welt, 2003
Walsh, Maria. "Jananne Al-Ani: Tate Britain London." *Art Monthly*
 no. 285 (April 2005): 24–25

Artist's Statement
What I think is interesting is the way in which artists from
"elsewhere" are more often than not defined by their biogra-
phies and not by the work they produce. At the other end of
the scale we get to know everything about establishment artists'
likes and dislikes: where they shop, what they feed their cats,
what their favourite color is . . . I'm not sure which is worse!
 —From an interview with Richard Hylton in Claire Doherty,
Angela Weight, and Hylton, *Jananne Al-Ani* (London: Film and
 Video Umbrella, 2005)

GHADA AMER

Born 1963 in Cairo, Egypt. Lives and works in New York

Education
1991 Institut des Hautes Études en Art Plastique, Paris
1989 Ecole des Beaux-Arts, Nice
1987 School of the Museum of Fine Arts, Boston
1986 Ecole des Beaux-Arts, Nice

Solo Exhibitions
2004 Institut Valencià d'Art Modern
The Reign of Terror. Davis Museum and Cultural Center,
 Wellesley College, Wellesley, Mass.
2003 *Forefront 45: Ghada Amer.* Indianapolis Museum of Art
Galleria Massimo Minini, Brescia
2002 De Appel, Centrum voor Beeldende Kunst, Amsterdam
Museum Kunst Palast, Düsseldorf
Works by Ghada Amer. San Francisco Art Institute
2001 *Ghada Amer: Pleasure.* Contemporary Arts Museum,
 Houston
Reading between the Threads. Henie-Onstad Kunstsenter,
 Høvikodden. Traveled: Museum Kunst Palast, Düsseldorf;
 Bildmuseet, Umeå
2000 Centre Culturel Contemporain, Tours
Intimate Confessions. Deitch Projects, New York. Traveled:
 Tel Aviv Museum of Art; Kunst-Werke Berlin
1999 Centro Andaluz de Arte Contemporáneo, Seville

Group Exhibitions
2005 *Always a Little Further.* Venice Biennale
TEXTures: Word and Symbol in Contemporary African Art.
 National Museum of African Art, Smithsonian Institution,
 Washington, D.C.
2004 *Africa Remix: Contemporary Art of a Continent.* Museum
 Kunst Palast, Düsseldorf. Traveled: Hayward Gallery, London;
 Musée national d'art moderne, Centre national d'art et de
 culture Georges Pompidou, Paris; Mori Art Museum, Tokyo
Beyond East and West: Seven Transnational Artists. Krannert Art
 Museum, University of Illinois, Champaign. Traveled: Louisiana
 State University Museum of Art, Baton Rouge; Hood Museum
 of Art, Dartmouth College, Hanover, N.H.; Williams College
 Museum of Art, Williamstown, Mass.
Looking Both Ways: Art of the Contemporary African Diaspora.
 The Museum for African Art, New York; Cranbrook Art Museum,
 Bloomfield Hills, Mich.; et al.
Monument to Now. Deste Foundation, Athens

2003 *Harem Fantasies and the New Scheherazades*. Centre de Cultura Contemporània de Barcelona. Traveled: Muséum d'Histoire Naturelle, Lyons

2001 *The Short Century: Independence and Liberation Movements in Africa, 1945–1994*. Museum Villa Stuck, Munich. Traveled: Martin-Gropius-Bau, Berlin; Museum of Contemporary Art, Chicago; P.S.1 Contemporary Art Center, Long Island City, New York

Uncommon Threads: Contemporary Artists and Clothing. Herbert F. Johnson Museum of Art, Cornell University, Ithaca

2000 *Greater New York: New Art in New York Now*. P.S.1 Contemporary Art Center, Long Island City, New York

Gwangju Biennale

Partage d'exotismes. Lyons Biennale

Whitney Biennial. Whitney Museum of American Art, New York

1999 *APERTO overALL*. Venice Biennale

1998 *Echolot*. Museum Fridericianum, Kassel

Loose Threads. Serpentine Gallery, London

1997 *Alternating Currents*. Johannesburg Biennale

French Kiss. Contemporary Art Gallery, Vancouver

Public Collections

Fonds Régionaux d'Art Contemporain (FRAC), Auvergne and Provence-Alpes-Côte d'Azur

The Art Institute of Chicago

Museum Kunst Palast, Düsseldorf

Hood Museum of Art, Dartmouth College, Hanover, N.H.

Sammlung Goetz, Munich

Musée national d'art moderne, Centre national d'art et de culture Georges Pompidou, Paris

Samsung Museum of Art, Seoul

Tel Aviv Museum of Art

Bibliography

Amer, Ghada, and Andrew Renton. *Ghada Amer*. New York: Gagosian Gallery, 2004

Auricchio, Laura. "Works in Translation: Ghada Amer's Hybrid Pleasures." *Art Journal* 60, no. 4 (Winter 2001): 27–37

Block, René, et al. *Echolot*. Exh. cat. Kassel: Museum Fridericianum, 1998

Ciscar, Consuelo, Jan-Erik Lundström, Teresa Millet, and Rosa Martinez. *Ghada Amer*. Exh. cat. Valencia: Institut Valencià d'Art Modern, 2004

Daftari, Fereshteh. "Beyond Islamic Roots—Beyond Modernism." *Res 43* (spring 2003): 175–86

Enwezor, Okwui, ed. *The Short Century: Independence and Liberation Movements in Africa 1945–1994*. Exh. cat. Munich and New York: Prestel, 2001

Guralnik, Nehama, et al. *Ghada Amer: Intimate Confessions*. Exh. cat. Tel Aviv: Tel Aviv Museum of Art, 2000

O'Brian, David, and David Prochaska. *Beyond East and West: Seven Transnational Artists*. Exh. cat. Champaign: Krannert Art Museum, 2004

Oguibe, Olu. "Love and Desire: The Art of Ghada Amer." *Third Text* no. 55 (Summer 2001): 63–74

Wendt, Selene. *Ghada Amer: Reading between the Threads*. Exh. cat. Høvikodden: Henie-Onstad Kunstsenter, 2001

Artist's Statement

So there is our origin that we transport with us and it transforms itself with the contact of the other cultures and it is a hybrid.

KUTLUG ATAMAN

Born 1961 in Istanbul, Turkey. Lives and works in Buenos Aires and Istanbul

Education
1988 University of California, Los Angeles
1985 University of California, Los Angeles
1983 Santa Monica College

Solo Exhibitions
2005 *Kuba*. Artangel, London. Traveled: Theater der Welt, Stuttgart
Kutlug Ataman: Perfect Strangers. Museum of Contemporary Art, Sydney
2004 *Stefan's Room*. Lehmann Maupin Gallery, New York
2003 Serpentine Gallery, London
2002 *The 4 Seasons of Veronica Read*. Lehmann Maupin Gallery, New York
Kutlug Ataman: Long Streams. Nikolaj Copenhagen Contemporary Art Center. Traveled: GEM, Museum voor Actuele Kunst, The Hague
Never My Soul! Lehmann Maupin Gallery, New York
A Rose Blooms in the Garden of Sorrows. Bawag Foundation, Vienna
2001 *Women Who Wear Wigs*. Lehmann Maupin Gallery, New York. Traveled: Istanbul Contemporary Art Museum

Group Exhibitions
2004 Carnegie International. Carnegie Museum of Art, Pittsburgh
Documentary Fictions. CaixaForum, Barcelona
Down Here. Bergen Kunsthall
The Turner Prize Exhibition. Tate Britain, London
2003 *Image Stream*. Wexner Center for the Arts, The Ohio State University, Columbus. Traveled: Deste Foundation, Athens; Kunsthalle Mannheim
Istanbul Biennial
Testimonies: Between Fiction and Reality. National Museum of Contemporary Art, Athens
2002 Documenta 11, Kassel
São Paulo Bienal
2001 Berlin Biennale
Istanbul Biennial
2000 Danish Film Institute
Melbourne International Film Festival
Tokyo International Lesbian & Gay Film Festival
1999 *APERTO overALL*. Venice Biennale
Berlin International Film Festival
Edinburgh International Film Festival
Istanbul International Film Festival
Stockholm International Film Festival

Public Collections
Dakis Joannou Collection, Athens
National Museum of Contemporary Art, Athens
Museo de Arte Contemporáneo de Castilla y León, Léon
Kunsthalle Mannheim
Sammlung Goetz, Munich
The Museum of Modern Art, New York
Carnegie Museum of Art, Pittsburgh
Museum Moderner Kunst, Vienna
Thyssen-Bornemisza Art Contemporary Privatstiftung, Vienna

Bibliography
Anton, Saul. "A Thousand Words: Kutlug Ataman talks about 1+1=1." *Artforum* 41, no. 6 (February 2003): 117–18
Ataman, Kutlug. *Kuba*. London: Artangel Trust, 2004
Gade, Rune, and Laura Hoptman. *Kutlug Ataman: Long Streams*. Exh. cat. Copenhagen: Nikolaj Copenhagen Contemporary Art Center, 2002
Honigman, Ana Finel. "What the Structure Defines: An Interview with Kutlug Ataman." *Art Journal* 63, no. 1 (Spring 2004): 79–86
Kent, Rachel. *Kutlug Ataman: Perfect Strangers*. Exh. cat. Sydney: Museum of Contemporary Art, 2005
Kortun, Vasif. "Kutlug Ataman: Women Who Wear Wigs." *Art Journal* 58, no. 4 (Winter 1999): 30–35
Rogoff, I. *Kutlug Ataman: A Rose Blooms in the Garden of Sorrows*. Exh. cat. Vienna: Bawag Foundation, 2002
Volk, Gregory. "Captivating Strangers." *Art in America* 92, no. 2 (February 2005): 84–91

THE ATLAS GROUP/WALID RAAD

Founded in 1999 in New York by Walid Raad. Raad born 1967 in Chbanieh, Lebanon. Lives and works in Brooklyn and Beirut

Education
1996 University of Rochester, New York
1993 University of Rochester, New York
1989 Rochester Institute of Technology, New York
1985 Boston University

Solo Exhibitions
2004 *The Atlas Group and Walid Raad: I Was Overcome with a Momentary Panic at the Thought That They Might Be Right: Documents from the Nassar Files in The Atlas Group Archive.* Art Gallery of York University, Toronto
Institute of International Visual Arts, London
The Truth Will Be Known When the Last Witness Is Dead: Documents from the Fakhouri File in The Atlas Group Archive. Prefix Institute of Contemporary Art, Toronto

Group Exhibitions
2005 *Greater New York: New Art in New York Now.* P.S.1 Contemporary Art Center, Long Island City, New York
Incorporated: A Recent (Incomplete) History of Infiltrations, Actions and Propositions Utilizing Contemporary Art. Contemporary Arts Center, Cincinnati
Information/Transformation. Extra City Center for Contemporary Art, Antwerp
What's New, Pussycat? Museum für Moderne Kunst, Frankfurt am Main
2004 *Beyond East and West: Seven Transnational Artists.* Krannert Art Museum, University of Illinois, Champaign. Traveled: Louisiana State University Museum of Art, Baton Rouge; Hood Museum of Art, Dartmouth College, Hanover, N.H.; Williams College Museum of Art, Williamstown, Mass.
Do You Believe in Reality? Taipei Biennial
The Interventionists: Art in the Social Sphere. MASS MoCA, North Adams, Mass.
Witness. Museum of Contemporary Art, Sydney
2003 *DisORIENTation.* Haus der Kulturen der Welt, Berlin
Venice Biennale
2002 Documenta 11, Kassel
Mapping Sitting: On Portraiture and Photography (curator). Palais des Beaux-Arts, Brussels. Traveled: SK Stiftung Kultur, Cologne; Kunstnernes Hus, Oslo; Haus der Kulturen der Welt, Berlin; et al.
Whitney Biennial. Whitney Museum of American Art, New York

2000 International Festival of Mediterranean Cinema
Whitney Biennial. Whitney Museum of American Art, New York

Public Collections
Museum for Contemporary Art, Athens
Museum für Moderne Kunst, Frankfurt am Main
Hamburger Kunsthalle
Tate Modern, London
The Museum of Modern Art, New York
National Gallery of Canada, Ottawa

Bibliography
Bassil, Karl, Zeina Maasri, Akram Zaatari, and Walid Raad. *Mapping Sitting: On Portraiture and Photography.* Exh. cat. Beirut: Mind the Gap Productions and Fondation Arabe pour l'Image, 2002
Gilbert, Alan. "Walid Raad." *Bomb Magazine,* Fall 2002, pp. 38–45
Kaplan, Janet A. "Flirtations with Evidence." *Art in America* 92, no. 9 (October 2004): 134–39, 169
Raad, Walid. "Bayrut Ya Beyrouth: Maroun Baghdadi's *Hors la vie* and Franco-Lebanese History." *Third Text* 36 (Fall 1996): 65–82
Raad, Walid, and The Atlas Group. *Volume I: The Truth Will Be Known When the Last Witness Is Dead: Documents from the Fakhouri File in The Atlas Group Archive.* Exh. cat. Cologne: Verlag der Buchhandlung Walther König, 2004
Rogers, Sarah. "Forging History, Performing Memory: Walid Raad's The Atlas Project." *Parachute* no. 108 (October/November/December 2002): 68–79
Smith, Lee. "Missing in Action: The Art of The Atlas Group/Walid Raad." *Artforum* 41, no. 6 (February 2003): 124–29

Artist's Statement
The Atlas Group (as a project, an imaginary foundation, as well as a set of documents) was the form that I gave between 1994 and 2004 to my explorations of the question of the photographic and videographic document in relation to the possibilities and limits of writing a history of Lebanon. Moreover, this form permitted me to think about how the notion of experience can be thought via the language of photography and video, especially when the experience in question is that of physical and psychological violence.

MONA HATOUM

Born 1952 in Beirut, Lebanon. Lives and works in London
and Berlin

Education
1981 Slade School of Fine Art, London
1979 Byam Shaw School of Art, London
1972 Beirut University College

Solo Exhibitions
2005 *Home and Away: The Strange Surrealism of Mona Hatoum.*
Douglas F. Cooley Memorial Art Gallery, Reed College,
Portland, Oreg.
Mona Hatoum: Over My Dead Body. Museum of Contemporary
Art, Sydney
2004 Hamburger Kunsthalle, Hamburg. Traveled: Kunstmuseum
Bonn; Magasin 3 Stockholm Konsthall
2003 Museo de Arte Contemporáneo de Oaxaca
2002 Centro de Arte de Salamanca. Traveled: Centro Galego
de Arte Contemporánea, Santiago de Compostela; Alexander
and Bonin, New York
2000 *Images from Elsewhere.* fig-1, London
Mona Hatoum: Domestic Disturbance. SITE Santa Fe. Traveled:
MASS MoCA, North Adams, Mass.
Mona Hatoum: The Entire World as a Foreign Land. Tate Britain,
London
1999 Castello di Rivoli, Turin
Le Creux de l'enfer, Centre d'art contemporain, Thiers. Traveled:
Le Frac Champagne-Ardenne, Reims; MUHKA, Antwerp
1998 Kunsthalle Basel
Modern Art Oxford. Traveled: Scottish National Gallery of
Modern Art, Edinburgh
1997 Museum of Contemporary Art, Chicago. Traveled:
The New Museum of Contemporary Art, New York
1996 De Appel, Amsterdam
Mona Hatoum: Current Disturbance. Capp Street Project,
San Francisco
Mona Hatoum: Quarters. Via Farini, Milan
1994 Musée national d'art moderne, Centre national d'art
et de culture Georges Pompidou, Paris

Group Exhibitions
2005 *Always a Little Further.* Venice Biennale
2004 *Beyond East and West: Seven Transnational Artists.*
Krannert Art Museum, University of Illinois, Champaign.
Traveled: Louisiana State University Museum of Art, Baton
Rouge; Hood Museum of Art, Dartmouth College, Hanover,
N.H.; Williams College Museum of Art, Williamstown, Mass.

2003 *Artist's Choice: Mona Hatoum, Here Is Elsewhere* (curator).
The Museum of Modern Art, New York
Banquet: Metabolism and Communication. Museum für Neue
Kunst, Karlsruhe
2002 Documenta 11, Kassel
2001 *The New World.* Valencia Bienal
2000 *No es sólo lo que ves. Pervirtiendo el minimalismo.*
Nacional Centro de Arte Reina Sofía, Madrid
1999 *Looking for a Place.* SITE Santa Fe Biennial
1998 Cairo Biennial
1997 Gwangju Biennale
Sensation: Young British Artists from the Saatchi Collection.
Royal Academy of Arts, London. Traveled: Hamburger
Bahnhof, Berlin; Brooklyn Museum of Art, New York
1996 *Inside the Visible: An Elliptical Traverse of 20th Century Art,
in, of, and from the Feminine.* The Institute of Contemporary
Art, Boston. Traveled: The National Museum of Women in the
Arts, Washington, D.C.; Whitechapel Art Gallery, London;
Art Gallery of Western Australia, Perth
1995 *Identity and Alterity.* Venice Biennale
Istanbul Biennial
The Turner Prize Exhibition. Tate Gallery, London
1994 *Sense and Sensibility: Women and Minimalism in the
Nineties.* The Museum of Modern Art, New York

Public Collections
Kunstmuseum Basel
Museum of Fine Arts, Boston
British Council, London
Tate Gallery, London
Los Angeles County Museum of Art
The Museum of Contemporary Art, Los Angeles
Musée national d'art moderne, Centre national d'art et
de culture Georges Pompidou, Paris
The Museum of Modern Art, New York
Philadelphia Museum of Art
San Francisco Museum of Modern Art

Bibliography
Garb, Tamar, Jo Glencross, and Janine Antoni. *Mona Hatoum.*
Exh. cat. Salamanca: Centro de Arte de Salamanca; Santiago
de Compostela: Centro Galego de Arte Contemporanea, 2002
Heinrich, Christoph, et al. *Mona Hatoum.* Exh. cat. Hamburg:
Hamburger Kunsthalle, 2004
Heinrich, Christoph, et al. *Mona Hatoum.* London: Phaidon
Press, 1997
Heon, Laura Steward, ed. *Mona Hatoum: Domestic Disturbance.*
Exh. cat. North Adams: MASS MoCA, 2001

Masséra, Jean-Charles. *Mona Hatoum*. Exh. cat. Reims: Le Collège editions/Frac Champagne-Ardenne, Thiers: Creux de l'Enfer/Centre d'art contemporain, and Antwerp: Museum van Hedendaagse Kunst, 2000

Morgan, Jessica, and Dan Cameron. *Mona Hatoum*. Exh. cat. Chicago: Museum of Contemporary Art, 1997

O'Brian, David, and David Prochaska. *Beyond East and West: Seven Transnational Artists*. Exh. cat. Champaign: Krannert Art Museum, 2004

Ohlin, Alix, et al. *Home and Away: The Strange Surrealism of Mona Hatoum*. Portland, Oreg.: Reed College, 2005

Said, Edward, and Sheena Wagstaff. *Mona Hatoum: The Entire World as a Foreign Land*. Exh. cat. London: Tate Gallery Publishing Ltd., 2000

van Assche, Christine, et al. *Mona Hatoum*. Exh. cat. Paris: Musée national d'art moderne, Centre national d'art et de culture Georges Pompidou, 1994

PIP HORNE

Born 1951 in Birmingham, England. Lives and works in London

Education
1977 Royal College of Art, London

Pip Horne is an architect with his own practice in London. His built projects include houses, artist's studios, apartments, office refurbishments, and an art gallery, and he has worked on many art-related projects, including collaborations with Anish Kapoor for Prada, Milan, in 1995, and with Jane and Louise Wilson at the BALTIC Centre for Contemporary Art, Gateshead, England, in 2003. For several years he has collaborated with Shirazeh Houshiary on sculpture/tower projects around the world, most recently for UBS bank in the City of London (2003); for Creative Time in New York's Battery Park (2004); and for a London playground project (2004) organized by Art for the World.

Artist's Statement
We come spinning out of nothingness, scattering stars like dust.
—Rumi
We want the work not to relate to any particular place or religion. Our interest is to discover and reveal our common origins and humanity and to transcend the confines of name and nationality. Like the scientist who suggests our beginnings are from stardust, we believe this is more relevant than boundaries created by man that only control our freedom.
—Shirazeh Houshiary and Pip Horne

SHIRAZEH HOUSHIARY

Born 1955 in Shiraz, Iran. Lives and works in London

Education
1980 Cardiff College of Art, Wales
1979 Chelsea School of Art, London

Solo Exhibitions
2004 *Breath*. Battery Park City, New York. Commissioned
 by Creative Time
Breath. Lisson Gallery, London
Works on Paper. Lehmann Maupin Gallery, New York
2003 Lehmann Maupin Gallery, New York
2000 *Self-Portraits*. Lisson Gallery, London
Tate Gallery Liverpool
1999 *Shirazeh Houshiary: Recent Works*. Lehmann Maupin,
 New York
1997 British Museum, London
1996 *Isthmus*. Le Magasin, Grenoble. Traveled: Museum Villa
 Stuck, Munich; Bonnefantenmuseum, Maastricht; Hochschule
 für angewandte Kunst, Vienna
1994 *The Sense of Unity*. Lisson Gallery, London
Turning around the Centre. University Gallery, University of
 Massachusetts Amherst. Traveled: Art Gallery of York
 University, Toronto; Samuel P. Harn Museum of Art, University
 of Florida, Gainesville

Group Exhibitions
2005 *Effervescence*. Musée des Beaux-Arts, Angers
2003 *Happiness*. Mori Art Museum, Tokyo
2002 *Skultur*. Basel
A Century of Innocence. Rooseum Center for Contemporary Art,
 Malmö
Thinking Big: Concepts for Twenty-first Century British Sculpture.
 Peggy Guggenheim Collection, Venice
2001 *Les Subsistances: Sculpture contemporaine*. Institut d'art
 contemporain, Lyons
1999 *Art Worlds in Dialogue*. Museum Ludwig, Cologne
1998 *10 Intensità in Europa*. Centro per l'arte contemporanea
 Luigi Pecci, Prato
1997 *Meditation*. Medersa Ben Youssef, Marrakesh
1996 São Paulo Bienal
1995 *Negotiating Rapture*. Museum of Contemporary Art, Chicago
1993 Venice Biennale
1989 *Magiciens de la terre*. Musée national d'art moderne,
 Centre national d'art et de culture Georges Pompidou, Paris

Public Collections
Rijksmuseum, Amsterdam
Stedelijk Museum, Amsterdam
Wadsworth Atheneum, Hartford
Tate Gallery, London
The Museum of Modern Art, New York
Kröller-Müller Museum, Otterlo

Bibliography
Daftari, Fereshteh. "Beyond Islamic Roots—Beyond
 Modernism." *Res 43* (Spring 2003): 175–86
———. "Shirazeh Houshiary/Pip Horne." In Alice Koegel, ed.
 Skulptur Biennale Munsterland 2003. Freiburg im Breisgau:
 modo Verlag, 2003, pp. 70–73, 142–43
Hutchinson, John. *Dancing around My Ghost: Shirazeh
 Houshiary*. Exh. cat. London: Camden Arts Centre, 1993
Kastner, Jeffrey. "Shirazeh Houshiary at Lehmann Maupin."
 Artforum 11, no. 4 (January 2004): 155
Morgan, Anne Barclay. "From Form to Formlessness: A
 Conversation with Shirazeh Houshiary." *Sculpture* 19, no. 6
 (July/August 2000): 24–29
———. *Shirazeh Houshiary: Turning around the Centre*. Exh. cat.
 Amherst: University Gallery, University of Massachusetts
 Amherst, 1993
Rose, Andrea, Jeremy Lewison, and Stella Santacatterina.
 Isthmus: Shirazeh Houshiary. Exh. cat. London: British Council,
 1995
Santacatterina, Stella. "Conversation with Shirazeh Houshiary."
 Third Text 27 (Summer 1994): 77–85

Artist's Statement
We come spinning out of nothingness, scattering stars like dust.
 —Rumi
We want the work not to relate to any particular place or religion.
Our interest is to discover and reveal our common origins and
humanity and to transcend the confines of name and nationality.
Like the scientist who suggests our beginnings are from star-
dust, we believe this is more relevant than boundaries created
by man that only control our freedom.
—*Shirazeh Houshiary and Pip Horne*

EMILY JACIR

Born 1970 in Memphis, Tennessee. Lives and works in Ramallah
and New York

Education
1999 Whitney Independent Study Program, Whitney Museum
of American Art, New York
1994 Memphis College of Art, Memphis
1992 University of Dallas, Irving

Solo Exhibitions
2004 *accumulations*. Kunstraum Innsbruck. Traveled: Alexander
and Bonin, New York
Khalil Sakakini Cultural Centre, Ramallah
Nuova Icona, Venice
2003 *belongings*. O.K. Centrum für Gegenwartskunst, Linz.
Traveled: Museum voor Moderne Kunst Arnhem
Where We Come From. Debs & Co., New York. Traveled:
Moderna Museet, Stockholm; Künstlerhaus, Bremen; Ulrich
Museum of Art, Wichita State University; The Jerusalem Fund
Gallery, Washington, D.C.
2002 *New Photographs: Bethlehem and Ramallah*. Debs & Co.,
New York
2000 *From Paris to Riyadh (Drawings for my mother)*. University
Gallery, University of the South, Sewanee
1999 *Everywhere/Nowhere*. SPACES, Cleveland
1997 Anderson Ranch Arts Center, Snowmass Village, Colo.
Eastfield College Gallery, Mesquite, Tex.

Group Exhibitions
2005 *Always a Little Further*. Venice Biennale
Belonging. Sharjah Biennial
Incontri Mediterranei. Parco Letterario Horcynus Orca, Messina
2004 *Election*. American Fine Arts, Co., New York
Gwangju Biennale
Non toccare la donna bianca. Fondazione Sandretto Re
Rebaudengo, Turin. Traveled: Castel dell'Ovo, Naples
Transcultures. National Museum of Contemporary Art, Athens
Wherever I Am. Modern Art Oxford
Whitney Biennial. Whitney Museum of American Art, New York
2003 *Cynical Culture*. Galerie Schüppenhauer, Cologne
Istanbul Biennial
Made in Palestine. Station Museum of Contemporary Art,
Houston
2002 *Queens International*. Queens Museum of Art, Flushing,
New York
Unjustified. Apex Art, New York
Veil. The New Art Gallery, Walsall. Traveled: Bluecoat Arts Centre

and Open Eye Gallery, Liverpool; Modern Art Oxford;
Kulturhuset, Stockholm
2000 *Ekbatana?* Nikolaj Contemporary Art Center, Copenhagen
Greater New York: New Art in New York Now. P.S.1 Contemporary
Art Center, Long Island City, New York
Worthless (Invaluable). Moderna galerija Ljubljana
1996 *. . . east of here. . . (re)imagining the 'orient'*. YYZ Artists'
Outlet, Toronto

Public Collections
National Museum of Contemporary Art, Athens
Ballroom Marfa, Tex.
Whitney Museum of American Art, New York
Kunstmuseum St. Gallen
Moderna Museet, Stockholm

Bibliography
Bailey, David A., and Gilane Tawadros, eds., *Veil: Veiling,
Representation and Contemporary Art*. Exh. cat. London:
inIVA, 2003
Demos, T. J. "Desire in Diaspora: Emily Jacir." *Art Journal*,
Winter 2003, pp. 68–78
Iles, Chrissie, Shamim M. Momim, and Debra Singer. *Whitney
Biennial 2004*. Exh. cat. New York: Whitney Museum of
American Art, 2004
Mack, Joshua. "Review: Emily Jacir: accumulations." *Modern
Painters* (June 2005): 111–12
Richard, Frances. "Reviews: Emily Jacir." *Artforum*, May 2005,
pp. 244–45
Said, Edward. "On Emily Jacir." *Grand Street* 72 (Fall 2003): 26
Said, Edward, et al. *Emily Jacir: belongings: Arbeiten/Works
1998–2003*. Exh. cat. Linz: O.K. Centrum für Gegenwartskunst,
2003
Vanderbilt, Tom. "Emily Jacir." *Artforum*, February 2004,
pp. 140–41
Waxman, Lori. "Picturing Failure." *Parachute* 115 (2004): 30

Y.Z. KAMI

Born 1956 in Tehran, Iran. Lives and works in New York

Education
1982 Conservatoire Libre du Cinéma Français, Paris
1981 Université Paris-Sorbonne
1975 University of California, Berkeley
1973 Holy Names College, Oakland

Solo Exhibitions
2003 *Portraits by Y. Z. Kami*. Herbert F. Johnson Museum of Art, Cornell University, Ithaca
2002 Weinstein Gallery, Minneapolis
2001 Deitch Projects, New York
1999 *Dry Land*. Deitch Projects, New York
1998 Deitch Projects, New York
1996 Holly Solomon Gallery, New York
1993 Barbara Toll Fine Arts, New York
1992 Barbara Toll Fine Arts, New York
Long Beach Museum of Art, Long Beach

Group Exhibitions
2005 Istanbul Biennial
2004 *Beyond East and West: Seven Transnational Artists*. Krannert Art Museum, University of Illinois, Champaign. Traveled: Louisiana State University Museum of Art, Baton Rouge; Hood Museum of Art, Dartmouth College, Hanover, N.H.; Williams College Museum of Art, Williamstown, Mass.
1997 *Projects 59: Architecture as Metaphor*. The Museum of Modern Art, New York
1996 *Inaugural Exhibition*. Hosfelt Gallery, San Francisco
Untitled. Center for Curatorial Studies, Bard College, Annandale-on-Hudson, N.Y.
1995 CARGO Marseille, Centre International d'Arts Visuels
1994 *. . . it's how you play the game*. Exit Art, New York

Public Collections
The Metropolitan Museum of Art, New York
Whitney Museum of American Art, New York

Bibliography
Azam Zanganah, Lila. "Y.Z. Kami." *La Règle du jeu* no. 26 (September 2004)
Ash, John. "Y.Z. Kami." *Artforum* 34, no. 7 (March 1996): 94–95
Balaschak, Christopher. "Y.Z. Kami." *Flash Art* 31, no. 200 (May/June 1998): 98
Breidenbach, Tom. "YZ Kami." *Artforum* 36, no. 9 (May 1998): 148
Daftari, Fereshteh. *Projects 59: Architecture as Metaphor*. Exh. brochure. New York: The Museum of Modern Art, 1997
Heartney, Eleanor. "Y.Z. Kami at Holly Solomon." *Art in America* 84 (November 1996): 115–16
Hirsch, Faye, and Andrea Inselmann. *The Watchful Portraits of Y.Z. Kami*. Exh. cat. Ithaca: Herbert F. Johnson Museum of Art, Cornell University, 2003
O'Brian, David, and David Prochaska. *Beyond East and West: Seven Transnational Artists*. Exh. cat. Champaign: Krannert Art Museum, 2004

Artist's Statement
Art has no country.

MIKE KELLEY

Born 1954 in Detroit, Michigan. Lives and works in Los Angeles

Education
1978 California Institute of the Arts, Valencia
1976 University of Michigan, Ann Arbor

Solo Exhibitions
2004 *Mike Kelley: The Uncanny*. Tate Gallery Liverpool. Traveled: Museum moderner Kunst Stiftung Ludwig Wein, Vienna
2000 *Categorical Imperative and Morgue*. Stedelijk Van Abbe Museum, Eindhoven
1999 *Mike Kelley: Two Projects*. Kunstverein Braunschweig
1997 Museu d'Art Contemporani de Barcelona. Traveled: Rooseum Center for Contemporary Art, Malmö; Stedelijk Van Abbe Museum, Eindhoven
1993 *Mike Kelley: Catholic Tastes*. Whitney Museum of American Art, New York. Traveled: Los Angeles County Museum of Art, Los Angeles; Haus der Kunst, Munich
1992 Kunsthalle Basel. Traveled: Portikus, Frankfurt am Main; Institute of Contemporary Arts, London
1991 *Mike Kelley: Half a Man*. Hirshhorn Museum and Sculpture Garden, Smithsonian Institution, Washington, D.C.

Group Exhibitions
2005 Gagosian Gallery, New York
100 Artists See God. Institute of Contemporary Arts, London
White: Whiteness and Race in Contemporary Art. International Center of Photography, New York
2004 *Disparities and Deformations*. SITE Santa Fe Biennial
Monument to Now: The Dakis Joannou Collection. Deste Foundation, Athens
2003 *Sod and Sodie Sock*. Biennale d'art Contemporain de Lyon, Lyons
2002 Whitney Biennial. Whitney Museum of American Art, New York
2000 *Destroy All Monsters: Postmodern Multimedia and Musical Mutations*. Center on Contemporary Art, Seattle
1998 *Mike Kelley and Paul McCarthy*. Vereinigung bildender Künstler Wiener Secession, Vienna
The Poetics Project 1977–1997. Musée national d'art moderne, Centre national d'art et de culture Georges Pompidou, Paris. Traveled: The Curve, Barbican Centre, London
1997 Documenta 10, Kassel

Public Collections
Museum of Contemporary Art, Chicago
Stedelijk Van Abbemuseum, Eindhoven
Los Angeles County Museum of Art
The Metropolitan Museum of Art, New York
The Museum of Modern Art, New York
Solomon R. Guggenheim Museum, New York
Musée national d'art moderne, Centre national d'art et de culture Georges Pompidou, Paris
Carnegie Museum of Art, Pittsburgh
Museum moderner Kunst, Vienna

Bibliography
Bartman, William S., and Miyoshi Barosh, eds. *Mike Kelley*. New York: A.R.T. Press, 1992
Kellein, Thomas. *Mike Kelley*. Exh. cat. Ostfildern: Hatje Cantz Verlag, 1992
Kelley, Mike. *Mike Kelley: Sublevel: Dim Recollection Illuminated by Multicolored Swamp Gas. Deodorized Central Mass with Satellites*. Exh. cat. Cologne: Verlag der Buchhandlung Walther König, 1999
Kelley, Mike, and John Welchman, ed. *Foul Perfection: Essays and Criticism*. Cambridge, Mass.: The MIT Press, 2003
Stals, Jose Lebrero, ed. *Mike Kelley: 1985–1996*. Exh. cat. Barcelona: Museu d'Art Contemporani de Barcelona, 1997
Sussman, Elisabeth, ed. *Mike Kelley, Catholic Tastes*. Exh. cat. New York: Whitney Museum of American Art, 1993
Welchman, John C., et al. *Mike Kelley*. London: Phaidon Press, 1999

RACHID KORAÏCHI

Born 1947 in Aïn Beïda, Algeria. Lives and works in Paris

Education
1977 École nationale supérieure des beaux-arts, Paris
1975 École nationale supérieure des arts décoratifs, Paris
1975 Institut d'Urbanisme de l'Académie de Paris
1971 École nationale supérieure des beaux-arts d'Alger, Algiers

Solo Exhibitions
2003 *Poem of Beirut*. Khalil Sakakini Cultural Centre, Ramallah
2002 *Path of Roses/Beirut's Poem/A Nation in Exile*. Herbert F. Johnson Museum of Art, Cornell University, Ithaca
Rachid Koraïchi: 7 variations autour de l'indigo. Centre de la Vieille Charité, Marseilles
2001 *Beirut's Poem and Path of Roses*. Jordan National Gallery of Fine Arts, Amman. Traveled: Institut français de Casablanca; Institut français de Marrakech, Marrakesh
1999 *L'Enfant Jazz*. Passage de l'Art, Marseilles. Traveled: Centre Départemental de Documentation Pédagogique, Avignon; Collège des Hautes Vallées, Guillestre
1998 Leighton House Museum, London
Lettres d'Argile: Hommage à Ibn Arabi. Espace Gard, Nîmes. Traveled: Darat al Funun, Centre Culturel Français d'Amman; Mustansiriya Madrasa, Centre Culturel Français de Bagdad, Baghdad; Centre Culturel Français de Damas, Damascus; et al.
1997 Darat al Funun, Amman
L'Enfant Jazz. Institut du Monde Arabe, Paris
1991 *Salomé*. Musée national d'art moderne, Centre national d'art et de culture Georges Pompidou, Paris

Group Exhibitions
2005 *Ensemble: Akeji, Hasquin, Koraïchi*. UNESCO, Paris
2001 *The Short Century: Independence and Liberation Movements in Africa, 1945–1994*. Museum Villa Stuck, Munich. Traveled: Martin-Gropius-Bau, Berlin; Museum of Contemporary Art, Chicago; P.S.1 Contemporary Art Center, Long Island City, New York
Unpacking Europe. Museum Boijmans Van Beuningen, Rotterdam
1999 *Authentic/Ex-centric: Africa in and out of Africa*. Venice Biennale
Global Conceptualism: Points of Origin, 1950s–1980s. Queens Museum of Art, Flushing, New York. Traveled: Walker Art Center, Minneapolis; Miami Art Museum; MIT List Visual Art Center, Cambridge, Mass.; et al.

1998 *Mediterranea: art contemporain des pays méditerranéens*. Jardin Botanique, Brussels
1997 Havana Bienal
Meditation. Medersa Ben Youssef, Marrakesh
Modernities and Memories. Venice Biennale. Traveled: Dolmabahce Cultural Center, Istanbul
Rhythm and Form: Visual Reflections on Arabic Poetry. Hallie Ford Museum of Art, Willamette University, Salem, Oreg. Traveled: Fine Arts Center Gallery, University of Arkansas; Worth Ryder Gallery, University of California, Berkeley
1996 *Arabish Tekens*. Museum voor Volkenkunde, Rotterdam
Art contemporain. Institut du Monde Arabe, Paris
Images of Africa Festival. Barbican Centre, London
Rencontres africaines. Centre Culturel Français de Cotonou, Benin. Traveled: Centre Culturel Français de Ouagadougou, Burkina Faso; Centre Culturel Français d'Abidjan, Côte d'Ivoire; Centre Culturel Français de Casablanca; et al.

Public Collections
Jordan National Gallery of Fine Arts, Amman
British Museum, London
Musée d'art Moderne de la Ville de Paris
Musée national des Arts d'Afrique et d'Océanie, Paris
Museum voor Volkenkunde, Rotterdam
Smithsonian Institution, Washington, D.C.

Bibliography
Butor, Michael, and Rachid Koraïchi. *Salomé*. Exh. cat. Geneva: Editart, 1991
Dadi, Iftikhar, and Salah Hassan, eds. *Unpacking Europe: Towards a Critical Reading*. Exh. cat. Rotterdam: NAi Publishers, 2001
de Pontcharra, Nicole, and Pierre Restany. *Cris-Ecrits: Rachid Koraïchi*. Brussels: Editions de Lassa, 1991
Ensemble: Akeji, Hasquin, Koraïchi. Exh. cat. Paris: UNESCO, 2005
Enwezor, Okwui, ed. *The Short Century: Independence and Liberation Movements in Africa, 1945–1994*. Exh. cat. Munich and New York: Prestel, 2001
Koraïchi, Rachid, and Maryline Lostia. *Rûmî: Le miroir infini*. Paris: Éditions Alternatives, 2001
Lostia, Maryline. "Rachid Koraïchi: A Celestial Architecture." In Salah Hassan and Olu Oguibe, eds. *Authentic/Ex-centric: Conceptualism in Contemporary African Art*. Exh. cat. Ithaca: Forum for African Arts, 2001, pp. 158–77
Saadi, Nourredine, and Jean-Louis Pradel. *Koraïchi*. Arles: Sindbad/Actes-Sud, 1999

Artist's Statement
The term "origin" poses the very questioning of creation. Is origin more important for an artist than the interior geography? I am referring to the creator's body, which keeps traces and memory of the initial cultural elements.I don't believe that the culture of a place belongs to a restricted group of people. It belongs to all humanity. Humanity is always cannibalizing what is being made.

SHIRIN NESHAT

Born 1957 in Qazvin, Iran. Lives and works in New York

Education
1982 University of California, Berkeley
1981 University of California, Berkeley
1979 University of California, Berkeley

Solo Exhibitions
2005 Hamburger Bahnhof, Museum für Gegenwart, Berlin
Hiroshima City Museum of Contemporary Art
Museo de Arte Contemporáneo de Castilla y León
2004 Auckland Art Gallery
2003 Contemporary Arts Museum, Houston
Miami Art Museum
Museo de Arte Moderno, Mexico City
Tooba. Asia Society, New York
2002 Castello di Rivoli Museo d'Arte Contemporanea, Turin
Walker Art Center, Minneapolis
2001 Hamburger Kunsthalle, Hamburg
Musée d'art contemporain de Montréal
2000 Dallas Museum of Art
Kunsthalle Wien, Vienna
Serpentine Gallery, London
Wexner Center for the Arts, Ohio State University, Columbus
1999 The Art Institute of Chicago
1998 Tate Gallery, London
Whitney Museum of American Art at Philip Morris, New York

Group Exhibitions
2005 *Beauty*. Haus der Kulturen der Welt, Berlin
Some Stories. Kunsthalle Wien, Vienna
Translation. Palais de Tokyo, Paris
2004 *Far Near Distance: Contemporary Positions of Iranian Artists*. Haus der Kulturen der Welt, Berlin
Monument to Now: The Dakis Joannou Collection. Deste Foundation, Athens
Tehran Museum of Contemporary Art
2003 *Bill Viola and Shirin Neshat*. The State Hermitage Museum, St. Petersburg
Harem Fantasies and the New Scheherazades. Centre de Cultura Contemporània de Barcelona. Traveled: Muséum d'Histoire Naturelle, Lyons
ICP Triennial. International Center of Photography, New York
Safavid. Asia Society, New York
2002 Documenta 11, Kassel
Moving Pictures. Solomon R. Guggenheim Museum of Art, New York

New Art. Tehran Museum of Contemporary Art

Visions from America. Whitney Museum of American Art,
 New York

2000 Gwangju Biennale

Greater New York: New Art in New York Now, P.S.1 Contemporary
 Art Center, Long Island City, New York.

Sydney Biennale

Whitney Biennial. Whitney Museum of American Art, New York

1999 Carnegie International. Carnegie Museum of Art, Pittsburgh

Looking for a Place. SITE Santa Fe

Project 70: Shirin Neshat, Simon Patterson, Xu Bing. The
 Museum of Modern Art, New York

Venice Biennale

1998 *On Life, Beauty, Translations and Other Difficulties*.
 Istanbul Biennial

Trade Routes: History and Geography. Johannesburg Biennale

Unfinished History. Walker Art Center, Minneapolis

1996 *Jurassic Technologies Revenant*. Sydney Biennal

1995 Istanbul Biennial

Venice Biennale

Public Collections

Dakis Joannou Collection, Athens

Walker Art Center, Minneapolis

The Museum of Modern Art, New York

Solomon R. Guggenheim Museum of Art, New York

Bibliography

Bonami, Francesco, Hamid Dabashi, and Octavio Zaya.
 Shirin Neshat: Women of Allah. Turin: Marco Noire, 1997

Brownson, Ron. *Through the Eyes of Shirin Neshat*. Exh. cat.
 Auckland: Auckland Art Gallery, 2004

Gagnon, Paulette, Shoja Azari, and Atom Egoyan. *Shirin Neshat*.
 Exh. cat. Musée d'art contemporain de Montréal, 2001

Naficy, Hamid, Ruth Noack, and Gerald Matt. *Shirin Neshat*.
 Exh. cat. Vienna: Kunsthalle Wien, and London: Serpentine
 Gallery, 2000

Neshat, Shirin, and Shoja Youssefi Azari. *Shirin Neshat:
 2002–2005*. Milan: Edizioni Charta, 2005

Tooba: Shirin Neshat. Mexico City: Museo de Arte Moderno, 2003

Verzotti, Giorgio, and RoseLee Goldberg. *Shirin Neshat*. Exh.
 cat. Milan: Edizioni Charta, 2002

Artist's Statement

As an artist who has spent many years apart from her country,
my art began, and has developed ever since, firstly as an
excuse to reconnect to my place of origin, to keep alive that
dissipating but meaningful relationship, but most of all to face
my own personal anxieties and obsessions in life.

MARJANE SATRAPI

Born 1969 in Rasht, Iran. Lives and works in Paris

Education

1994 Ecole Supérieure des Arts Décoratifs de Strasbourg

1989 University of Tehran

Solo Exhibitions

2005 Centrale Bibliotheek, Rotterdam

Group Exhibitions

2005 *Drawn-Out Stories: Art of Graphic Novels*. Toronto
 Reference Library

Komikazen Festival. Associazione Culturale Mirada, Ravenna

West by East. Centre de Cultura Contemporània de Barcelona

2004 *Far Near Distance: Contemporary Positions of Iranian
 Artists*. Haus der Kulturen der Welt, Berlin

2003 *Haft: 7 artistes contemporains iraniens*. Espace Landowski,
 Boulogne-Billancourt

2000 Centre Belge de la Bande Dessinée, Brussels

International Comics Festival, Angoulême

Bibliography

de La Morandière, Marilys, and Michket Krifa. *Haft: 7 artistes
 contemporains iraniens*. Exh. cat. Paris: Somogy, 2003

Heller, Steven. "Marjane Satrapi: A Graphic Memoir." *Eye* 13,
 no. 50 (Winter 2003): 76–79

Satrapi, Marjane. *Persepolis: The Story of a Childhood*.
 New York: Pantheon, 2003

———. *Persepolis 2: The Story of a Return*. New York: Pantheon,
 2004. *Persepolis* was first published in four parts by
 L'Association, Paris

———. *Poulet aux prunes*. Paris: L'Association, 2004

———. *Embroideries*. New York: Pantheon, 2005

———. "Veiled Threat." *The Guardian*, December 12, 2003

Storace, Patricia. "A Double Life in Black and White."
 The New York Review of Books 52, no. 6 (April 7, 2005)

Tully, Annie. "An Interview with Marjane Satrapi." Bookslut.
 http://www.bookslut.com/features/2004_10_003261.php

Weich, Dave. "Author Interviews: Marjane Satrapi Returns."
 Powells.com. http://www.powells.com/authors/satrapi.html

SHIRANA SHAHBAZI

Born 1974 in Tehran, Iran. Lives and works in Zurich

Education
2000 Hochschule für Gestaltung und Kunst, Zurich
1997 Fachhochschule Dortmund

Solo Exhibitions
2005 *Accept the Expected.* Centre d'Art Contemporain Genève, Geneva
Galerie Bob van Orsouw, Zurich
Graceland. Silk Road Photography and Art Gallery, Tehran
2004 *Flowers, Fruits, and Portraits.* Salon 94, New York
TRANS>area, New York
The Wrong Gallery, New York
2003 *The Garden: Shirana Shahbazi.* Temple Bar Gallery & Studios, Dublin
Goftare Nik/Good Words. Museum of Contemporary Photography, Chicago
Swiss Institute, New York
2002 Bonner Kunstverein, Bonn
Galerie Bob van Orsouw, Zurich
2001 *Goftare Nik/Good Words.* The Photographer's Gallery, London

Group Exhibitions
2005 *Universal Experience: Art, Life, and the Tourist's Eye.* Museum of Contemporary Art, Chicago. Traveled: Hayward Gallery, South Bank Centre, London
Between New Painting and Political Action. Prague Biennale
Sharjah Biennial
2004 *Far Near Distance: Contemporary Positions of Iranian Artists.* Haus der Kulturen der Welt, Berlin
Non toccare la donna bianca. Fondazione Sandretto Re Rebaudengo, Turin. Traveled: Castel dell'Ovo, Naples
2003 *Black My Story.* Museum De Paviljoens, Almere
Delays and Revolutions. Venice Biennale
Girls' Night Out. Orange County Museum of Art, Newport Beach. Traveled: Addison Gallery of American Art, Andover, Mass.; Aspen Art Museum; Contemporary Art Museum St. Louis; et al.
Haft: 7 artistes contemporains iraniens. Espace Landowski, Boulogne-Billancourt
Identität Schreiben/Writing Identity: Autobiografie in der Kunst. Galerie für Zeitgenössische Kunst, Leipzig
Nation. Frankfurter Kunstverein, Frankfurt am Main
Outlook. Benaki Museum, Athens
2002 *Balsam: Exhibition der Fussballseele.* Helmhaus, Zurich
The Citigroup Private Bank Photography Prize. The Photographer's Gallery, London

Faces, People and Society. Frans Hals Museum, Haarlem
Protest! Respect! Kunsthalle St. Gallen
2001 *heimaten.* Galerie für Zeitgenössische Kunst, Leipzig
M family. Migros Museum für Gegenwartskunst, Zurich
Das Versprechen der Fotografie. Schirn Kunsthalle, Frankfurt am Main
2000 *Diplomausstellung.* Hochschule für Gestaltung und Kunst Zurich
1999 *The World We Grow Into.* AVRO Keizersgracht, Amsterdam

Bibliography
Carver, Antonia, ed. *Blink: 100 photographers, 10 curators, 10 writers.* London: Phaidon Press, 2002
de La Morandière, Marilys, and Michket Krifa. *Haft: 7 artistes contemporains iraniens.* Exh. cat. Paris: Somogy, 2003
Garcia-Anton, Katya, ed. *Shirana Shahbazi: Accept the Expected.* Exh. cat. Cologne: Verlag der Buchhandlung Walther König, 2005
Issa, Rose, et al. *Far Near Distance: Contemporary Positions of Iranian Artists.* Exh. cat. Berlin: Haus der Kulturen der Welt, 2004
Jacobson, Karen, ed. *Girl's Night Out.* Exh. cat. Newport Beach: Orange County Museum of Art, 2003
Krebs, Manuel, Shirana Shahbazi, and Tirad Zolghadr. *SHAHRZAD #1: Shahrzad.* Self-published, 2002
———. *SHAHRZAD #2: Oil.* Self-published, 2002
———. *SHAHRZAD #3: The Americas.* Self-published, 2003
———. *SHAHRZAD #4: Jamaran.* Self-published, 2004
Lee, Christopher Joon-Hai, et al. *Black My Story.* Exh. cat. Almere: Museum De Paviljoens, 2003
Pohlen, Annelie, and Tan Wälchli. *Shirana Shahbazi.* Exh. cat. Bonn: Bonner Kunstverein, 2002
Robecchi, Michele. "Shirana Shahbazi: You Are Here." *Flash Art International* 36, no. 233 (November/December 2003): 76–79
Ruf, Beatrix, and Tirad Zolghadr. *Shirana Shahbazi: Goftare Nik/Good Words.* Exh. cat. Zurich: codax publisher, 2001

Artist's Statement
I believe that if there is any kind of truth or understanding to be gained from a work of art or a text it is not easily apparent and needs to be looked for in between the lines. The same applies to the importance of origin in an artist's work. I grew up in an unreligious family, but if we claim that the sheer context of an islamic society in which I spent my childhood, or the fact that my hair is black and so on, must have influenced my work and decisions in a relevant way, then we should not forget about any other context to which an artist and the work travel, such as the context of an exhibition of contemporary art (in the NY MoMA for example), or of societies in the West where there is the desire to label and classify according to nationality and religion.

RAQIB SHAW

Born 1974 in Calcutta, India. Lives and works in London

Education
2002 Central Saint Martins College of Art and Design, London
2001 Central Saint Martins College of Art and Design, London

Solo Exhibitions
2005 *Raqib Shaw: Garden of Earthly Delights*. Deitch Projects, New York
2004 *Raqib Shaw: Garden of Earthly Delights*. Victoria Miro Gallery, London

Group Exhibitions
2004 *Plantmania! Art and the World of Plants*. Sunderland Museum & Winter Gardens
2003 *Nature and Nation: Vaster Than Empires*. Hastings Museum and Art Gallery. Traveled: Worcester City Art Gallery; The Yard Gallery, Nottingham; Lethaby Gallery, Central Saint Martins College of Art and Design, London
2002 Chancellor's Forum Exhibition. London College of Fashion
Direction 2002. The London Institute at Millbank
2001 *Future Map 2001*. Lethaby Gallery, Central Saint Martins College of Art and Design, London

Public Collections
The London Institute
University of the Arts, London
Victoria and Albert Museum, London
Rubell Family Collection, Miami
The Museum of Modern Art, New York
Seattle Art Museum, Seattle

Bibliography
Dyer, Richard. "Raqib Shaw in Conversation." *Wasafiri* no. 42 (Summer 2004): 68–77
Exley, Roy. "Raqib Shaw." *Flash Art* no. 236 (May/June 2004): 142
Rimanelli, David. *Garden of Earthly Delights*. Exh. cat. New York: Deitch Projects, 2005
Torrigiani, Massimo. "Raqib Shaw: Studio Visit." *Boiler* no. 4 (2004): 24–31
Williams, Eliza. "Raqib Shaw." *Tema Celeste*, June 2004, p. 98

Artist's Statement
I consider my work to be a result of my continuing dialogue with the symbolic, historical, and cultural encyclopedism that I have absorbed over the years. Manmade boundaries are irrelevant to inspiration, imagination, and learning when our world is shrinking. It is an encouraging idea if mental borders are broken and the inevitability of the fusion of ideas across the globe is allowed to exist free from rigid grouping and fixed nomenclature.

SHAHZIA SIKANDER

Born 1969 in Lahore, Pakistan. Lives and works in New York

Education
1995 Rhode Island School of Design, Providence
1992 National College of Arts, Lahore

Solo Exhibitions
2005 *Shahzia Sikander: Dissonance to Detour*. Ben Maltz Gallery, Otis College of Art and Design, Los Angeles
2004 *Shahzia Sikander: Flip Flop*. The San Diego Museum of Art
Shahzia Sikander: Nemesis. Tang Teaching Museum and Art Gallery at Skidmore College, Saratoga Springs. Traveled: The Aldrich Museum of Contemporary Art, Ridgefield, Conn.
2001 *Intimacy*. Artpace San Antonio
2000 *Acts of Balance*. Whitney Museum of American Art at Philip Morris, New York
1999 *Directions: Shahzia Sikander*. Hirshhorn Museum and Sculpture Garden, Smithsonian Institution, Washington, D.C.
1998 *Shahzia Sikander: Drawings and Miniatures*. Kemper Museum of Contemporary Art and Design, Kansas City, Mo.
The Renaissance Society at the University of Chicago

Group Exhibitions
2005 *Always a Little Further*. Venice Biennale
Fatal Love: South Asian American Art Now. Queens Museum of Art, Flushing, New York
New Work/New Acquisitions. The Museum of Modern Art, New York
2004 *Beyond East and West: Seven Transnational Artists*. Krannert Art Museum, University of Illinois, Champaign. Traveled: Louisiana State University Museum of Art, Baton Rouge; Hood Museum of Art, Dartmouth College, Hanover, N.H.; Williams College Museum of Art, Williamstown, Mass.
2003 *Poetic Justice*. Istanbul Biennial
2002 *Drawing Now: Eight Propositions*. The Museum of Modern Art, New York
Urgent Painting. Musée d'art Moderne de la Ville de Paris
2001 *ARS 01*. Kiasma Museum of Contemporary Art, Helsinki
Conversations with Traditions, Nilima Sheikh and Shahzia Sikander. Asia Society, New York. Traveled: Middlebury College Museum of Art, Middlebury, Vermont; Royal Ontario Museum, Toronto; Seattle Art Museum; et al.
2000 *Projects 70: Janine Antoni, Shahzia Sikander, Kara Walker*. The Museum of Modern Art, New York
Greater New York: New Art in New York Now. P.S.1 Contemporary Art Center, Long Island City, New York

1999 *The American Century: Art and Culture 1900–2000, Part II.*
 Whitney Museum of American Art, New York
Asia-Pacific Triennial
1997 Whitney Biennial. Whitney Museum of American Art, New York
Public Collections
The Museum of Modern Art, New York
Whitney Museum of American Art, New York
Museum of Art, Rhode Island School of Design Art, Providence

Bibliography
Azimi, Negar. "Interview: Shahzia Sikander." *Bidoun* 1, no. 3
 (Winter 2005): 104–8
Berry, Ian, and Jessica Hough. *Shahzia Sikander: Nemesis.*
 Exh. cat. Saratoga Springs: The Tang Teaching Museum and
 Art Gallery at Skidmore College, 2004
Daftari, Fereshteh. "Beyond Islamic Roots—Beyond Modernism."
 Res 43 (Spring 2003): 175–86
———. *Projects 70: Janine Antoni, Shahzia Sikander, Kara Walker.*
 Exh. brochure. New York: The Museum of Modern Art, 2000
Desai, Vishakha N. *Conversations with Traditions: Nilima Sheikh
 and Shahzia Sikander.* Exh. cat. New York: Asia Society, 2001
Devji, Faisal, and Homi Bhabha. *Shahzia Sikander.* Exh. cat.
 Chicago: The Renaissance Society, University of Chicago, 1999
Hamid, Mohsin, et al. *Shahzia Sikander: 51 Ways of Looking.*
 Exh. cat. New York: Sikkema Jenkins & Co, 2005
Hoptman, Laura. *Drawing Now: Eight Propositions.* Exh. cat.
 New York: The Museum of Modern Art, 2002
O'Brian, David, and David Prochaska. *Beyond East and West:
 Seven Transnational Artists.* Exh. cat. Champaign: Krannert
 Art Museum, 2004
Pollack, Barbara. "The New Look of Feminism." *Art News* 100,
 no. 8 (September 2001): 132–36
Singer, Debra. *Shahzia Sikander: Acts of Balance.* Exh. brochure.
 New York: Whitney Museum of American Art at Philip Morris,
 2000

BILL VIOLA

Born 1951 in New York, New York. Lives and works in Long Beach

Education
1973 College of Visual and Performing Arts, Syracuse University

Solo Exhibitions
2005 *Bill Viola Visions*. Aros Aarhus Kunstmuseum, Aarhus,
 Denmark
2004 *Bill Viola: Five Angels for the Millennium*. Whitney Museum
 of American Art, New York
2003 *Bill Viola: The Passions*. The J. Paul Getty Museum,
 Los Angeles. Traveled: National Gallery, London; Pinakotheks
 of the Bayerische Staatsgemäldesammlungen, Munich; Sala
 de Exposiciones de la Fundación "la Caixa," Madrid; et al.
2002 *Bill Viola: Going Forth by Day*. Deutsche Guggenheim
 Berlin. Traveled: Solomon R. Guggenheim Museum, New York
2001 *Bill Viola: The Quintet of Remembrance*. The Metropolitan
 Museum of Art, New York
Bill Viola: Stations. Museum für Neue Kunst, Karlsruhe
1997 *Bill Viola: A Twenty-Five Year Survey*. Whitney Museum
 of American Art, New York. Traveled: Los Angeles County
 Museum of Art; Stedelijk Museum, Amsterdam; Museum
 für Moderne Kunst and Schirn Kunsthalle, Frankfurt am Main;
 et al.
Bill Viola: Fire, Water, Breath. Guggenheim Museum SoHo,
 New York
1995 *Buried Secrets*. Venice Biennale. Traveled: Kestner-
 Gesellschaft, Hannover; Arizona State University Art Museum,
 Tempe; Institute of Contemporary Art, Boston
1992 *Unseen Images*. Kunsthalle Düsseldorf. Traveled: Moderna
 Museet, Stockholm; Museo Nacional Centro de Arte Reina
 Sofía, Madrid; Musée cantonal des Beaux-Arts, Lausanne; et al.
1987 *Bill Viola: Installations and Videotapes*. The Museum of
 Modern Art, New York
1984 Musée d'Art Moderne de la Ville de Paris
1982 Whitney Museum of American Art, New York
1979 *Projects: Bill Viola*. The Museum of Modern Art, New York
1973 *New Video Works*. Everson Museum of Art, Syracuse

Group Exhibitions
2005 *Getting Emotional*. The Institute of Contemporary Art,
 Boston
2003 *Bill Viola and Shirin Neshat*. The State Hermitage Museum,
 St. Petersburg
2001 *Plateau of Humankind*. Venice Biennale
1996 *Being and Time: The Emergence of Video Production*.
 Albright-Knox Art Gallery, Buffalo. Traveled: Cranbrook Art

Museum, Bloomfield Hills, Mich.; Portland Art Museum,
Portland, Oreg.; Contemporary Arts Museum, Houston; et al.
1992 Documenta 9, Kassel
1989 Carnegie International. Carnegie Museum of Art, Pittsburgh

Public Collections
Stedelijk Museum, Amsterdam
Hamburger Bahnhof, Museum für Gegenwart, Berlin
Dallas Museum of Art
The Museum of Modern Art, New York
Solomon R. Guggenheim Museum, New York
Carnegie Museum of Art, Pittsburgh

Bibliography
Bellour, Raymond. "An Interview with Bill Viola." *October* no. 34
 (fall 1985): 91–119
Hyde, Lewis, Kira Perov, David A. Ross, and Bill Viola. *Bill Viola:
 A Twenty-Five-Year Survey*. Exh. cat. New York: Whitney
 Museum of American Art, in association with Flammarion, Paris
Krogh, Anna, and Jens Erik Sørensen. *Bill Viola: Visions*. Exh.
 cat. Aarhus: Aros Aarhus Kunstmuseum, 2005
Townsend, Chris, ed. *The Art of Bill Viola*. London: Thames &
 Hudson, 2004
Viola, Bill. *Bill Viola: Statements by the Artist*. Exh. cat.
 Los Angeles: Museum of Contemporary Art, 1985
Violette, Robert, ed. *Reasons for Knocking at an Empty House:
 Writings 1973–1994*. Cambridge: The MIT Press, 1995
Walsh, John, ed. *Bill Viola: The Passions*. Exh. cat. Los Angeles:
 J. Paul Getty Trust Publications, 2003

Index of the Plates

Photograph Credits

Trustees of The Museum of Modern Art